Serve

Written and Illustrated
by
Jacquelyn Jaie Fourgerel

Military

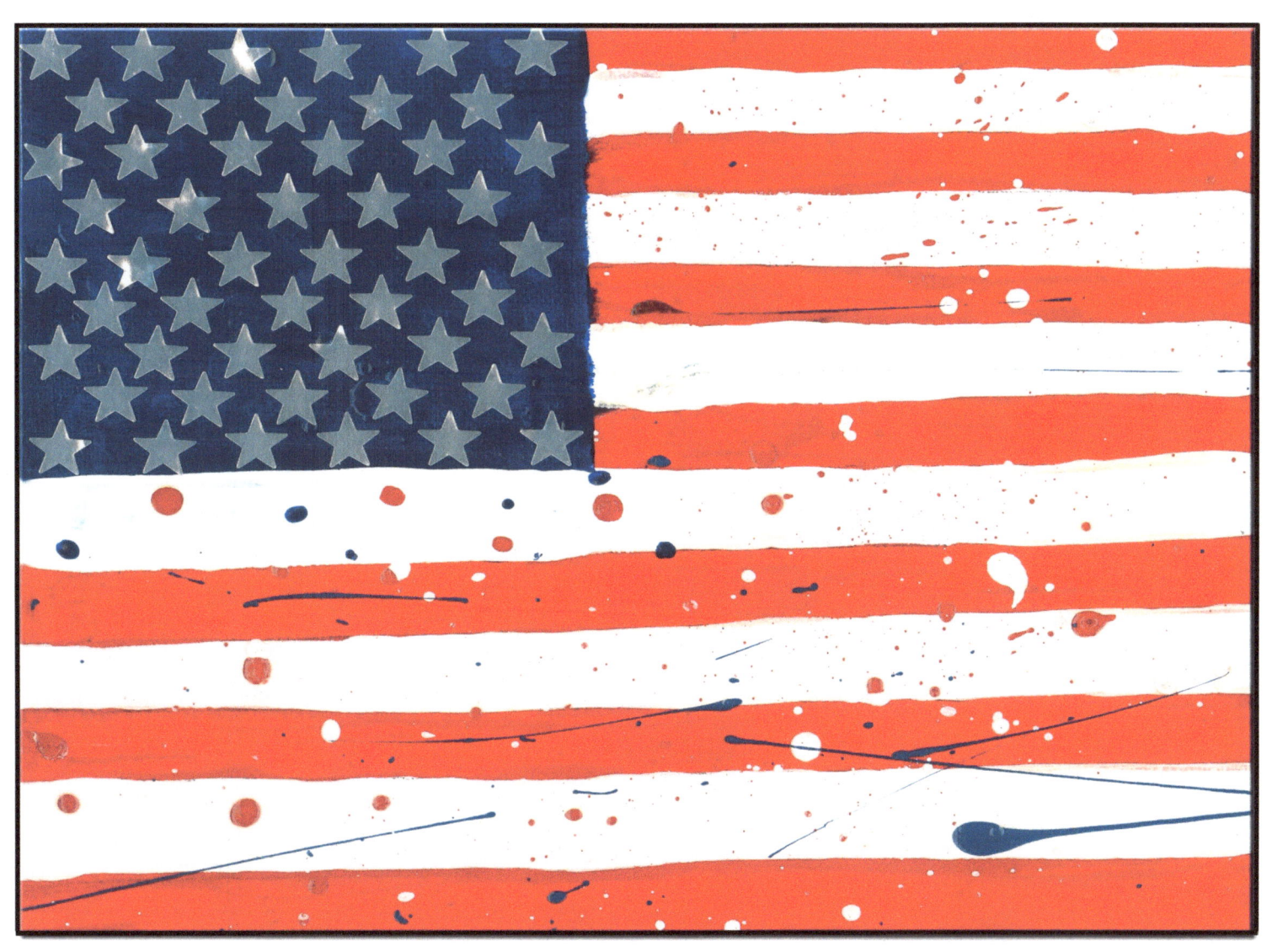

Police Officer

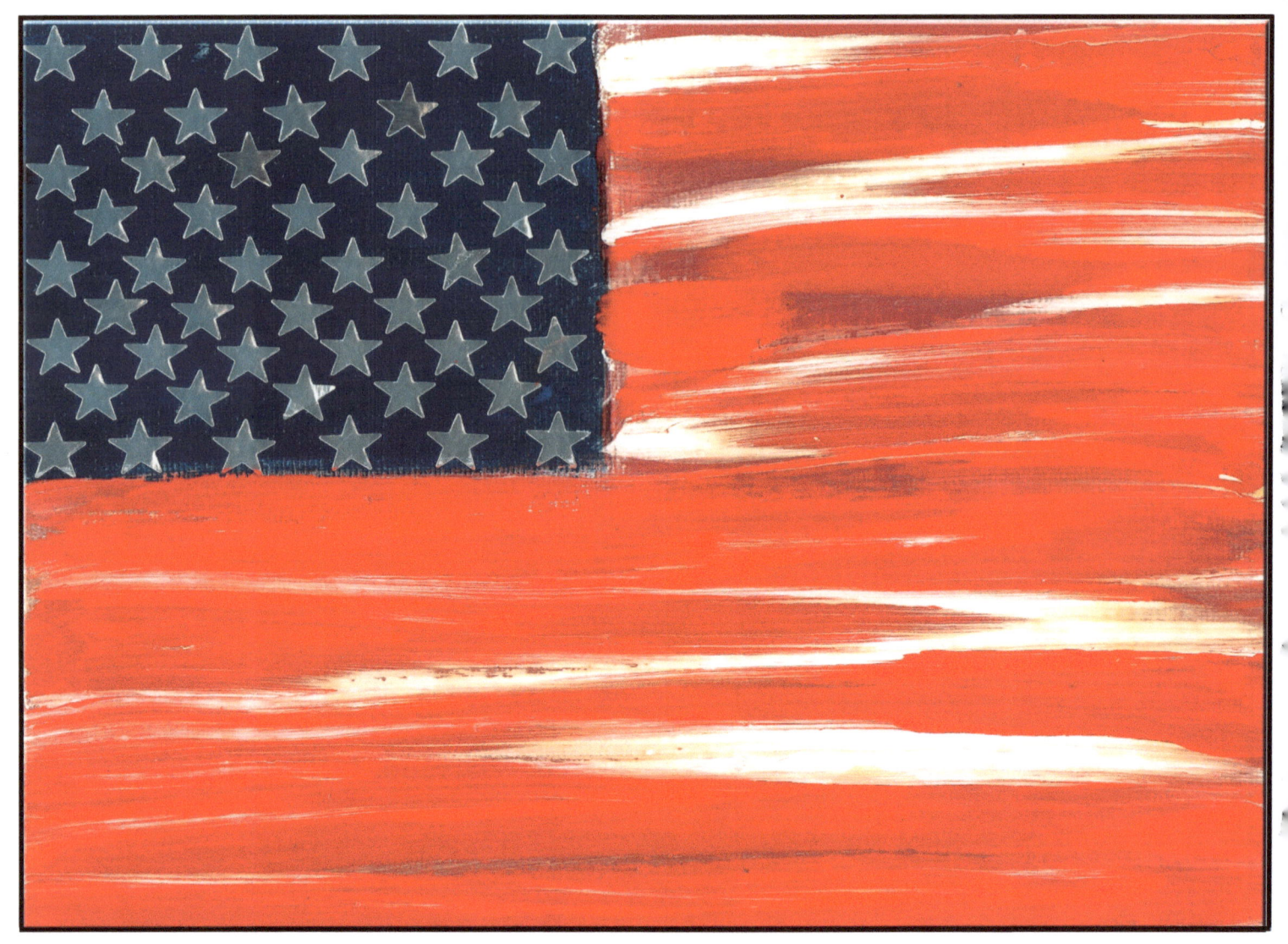

Firefighter

3

Emergency Medical Technician

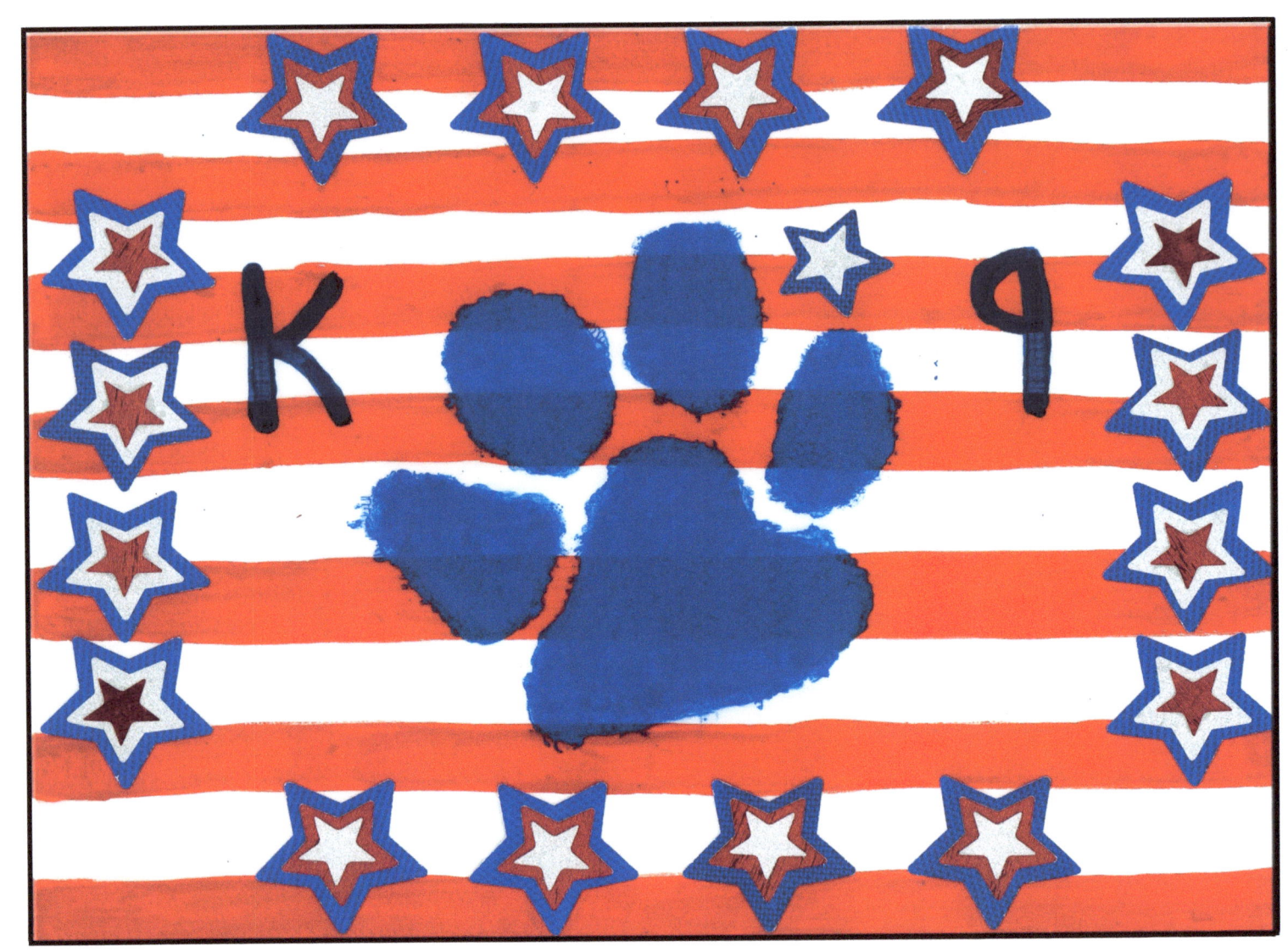

K-9 Unit

Best Friend

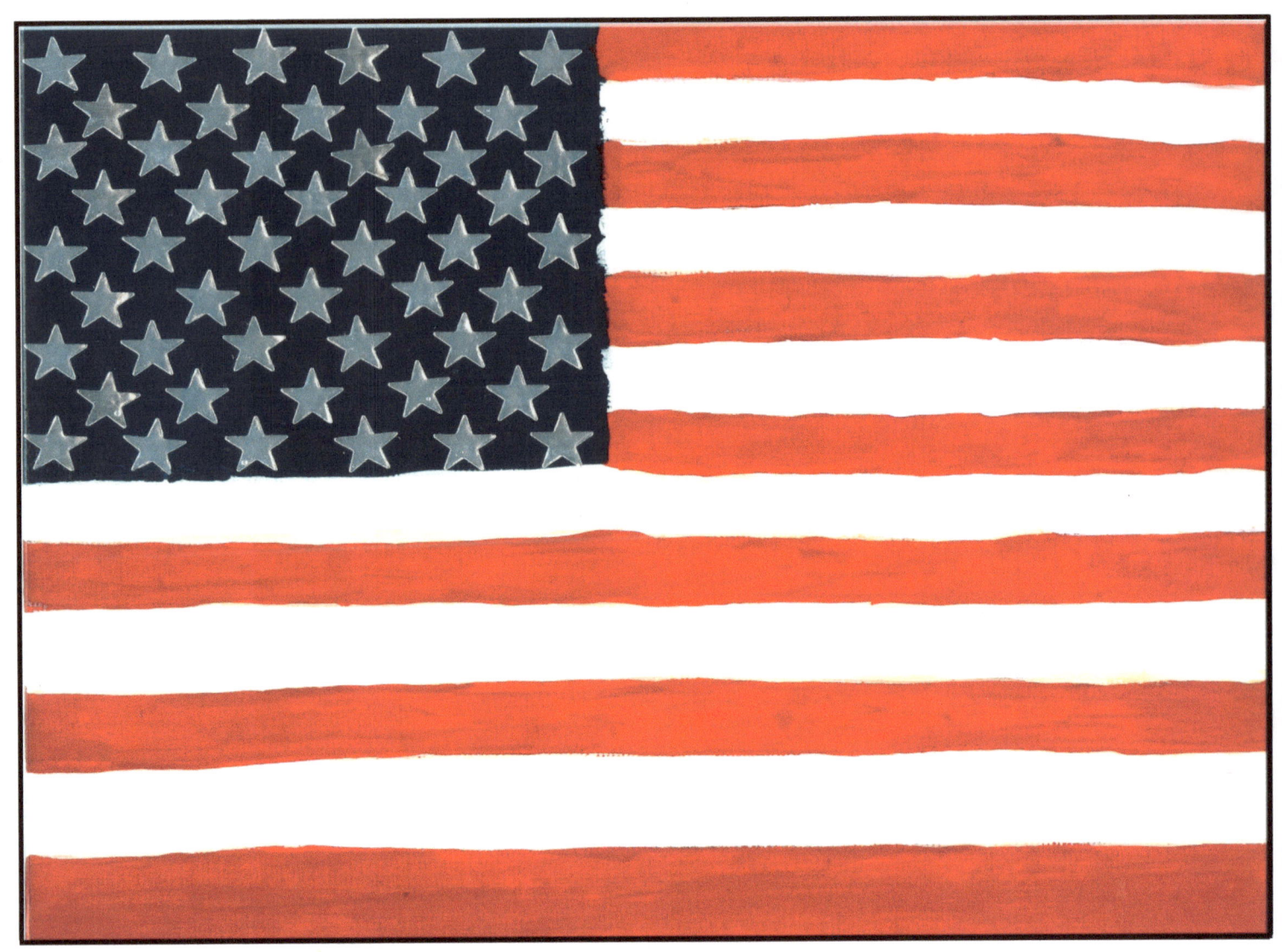

United States of America

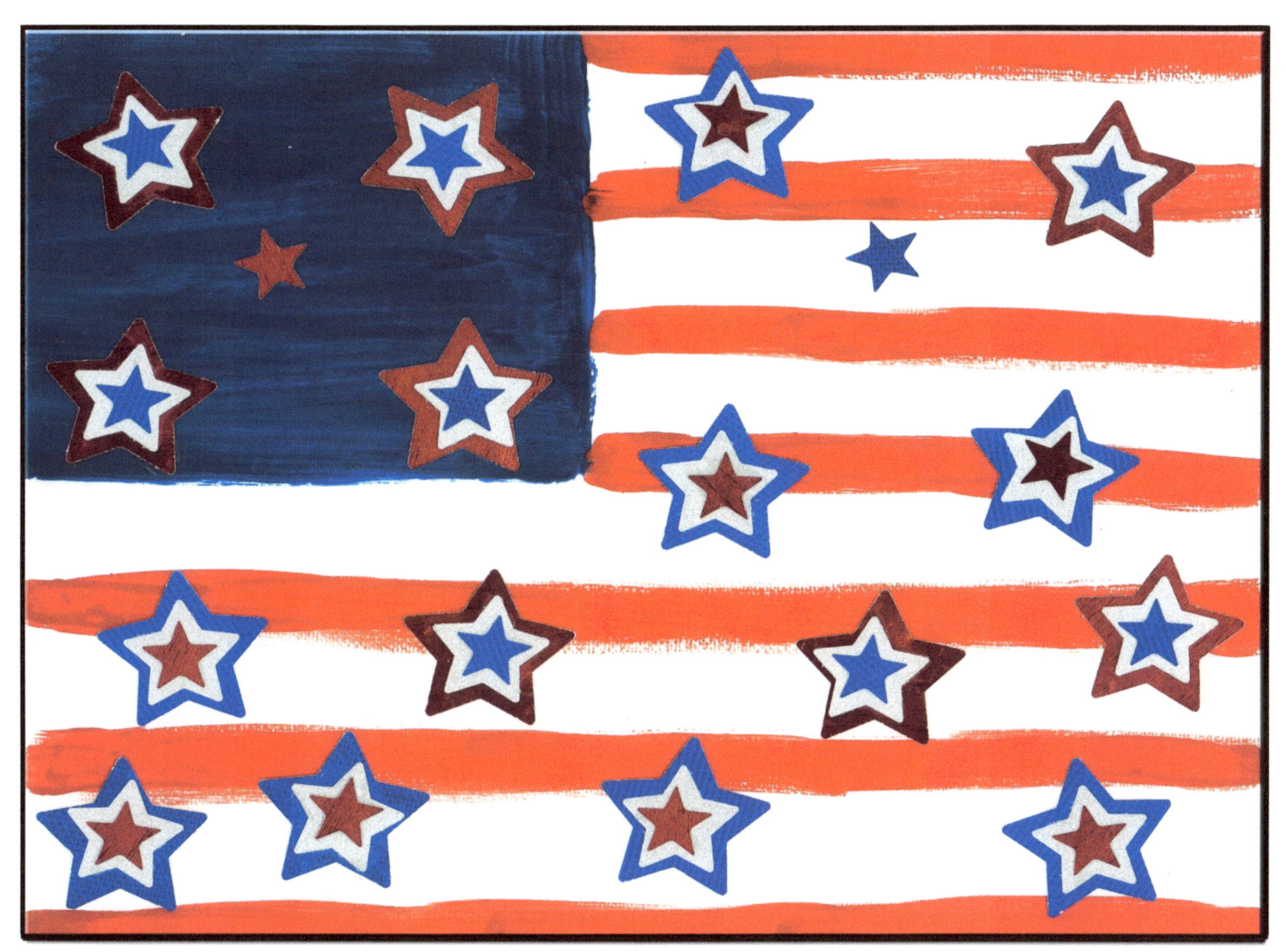

Stars and Stripes

Oath

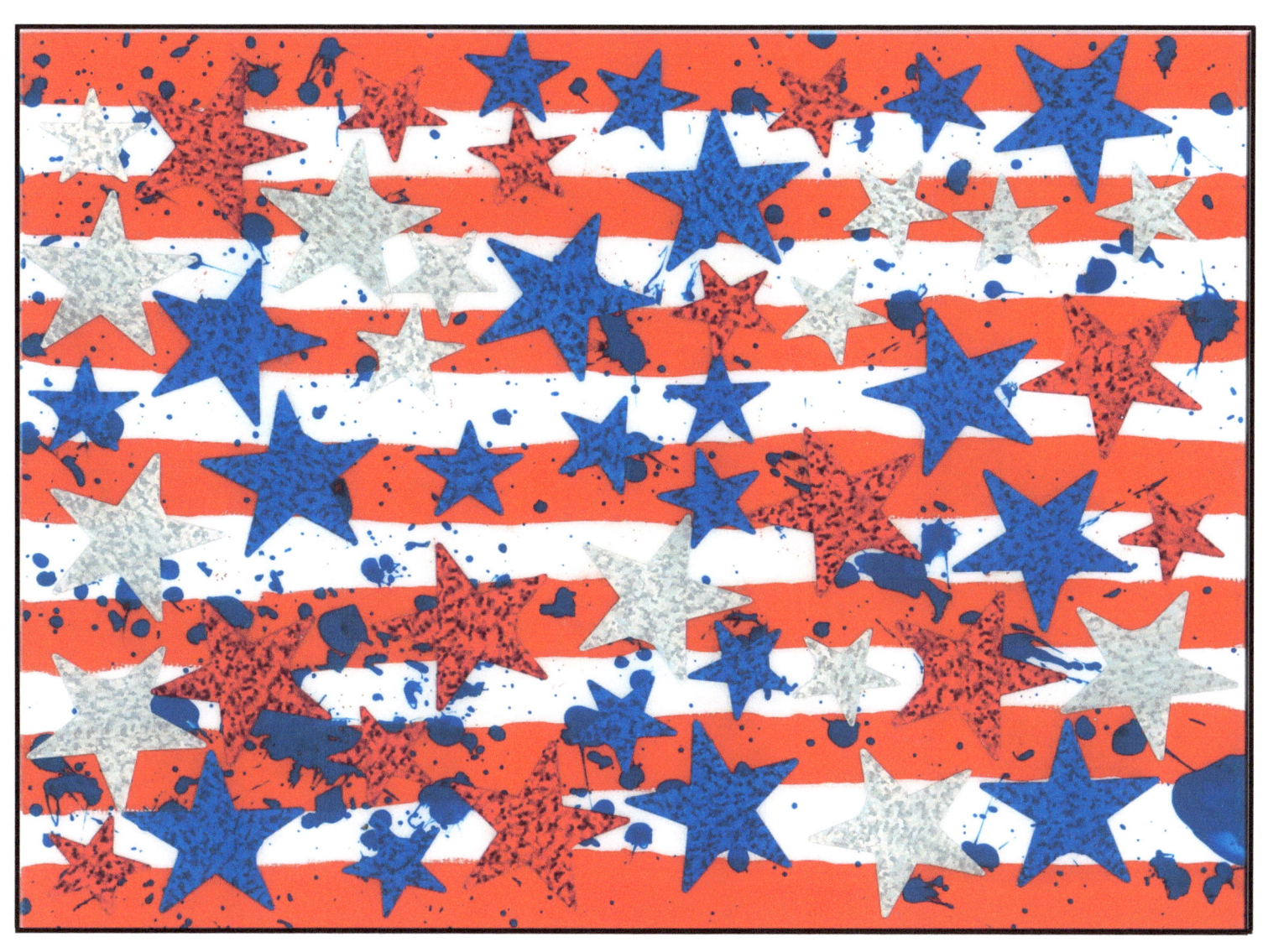

Duty

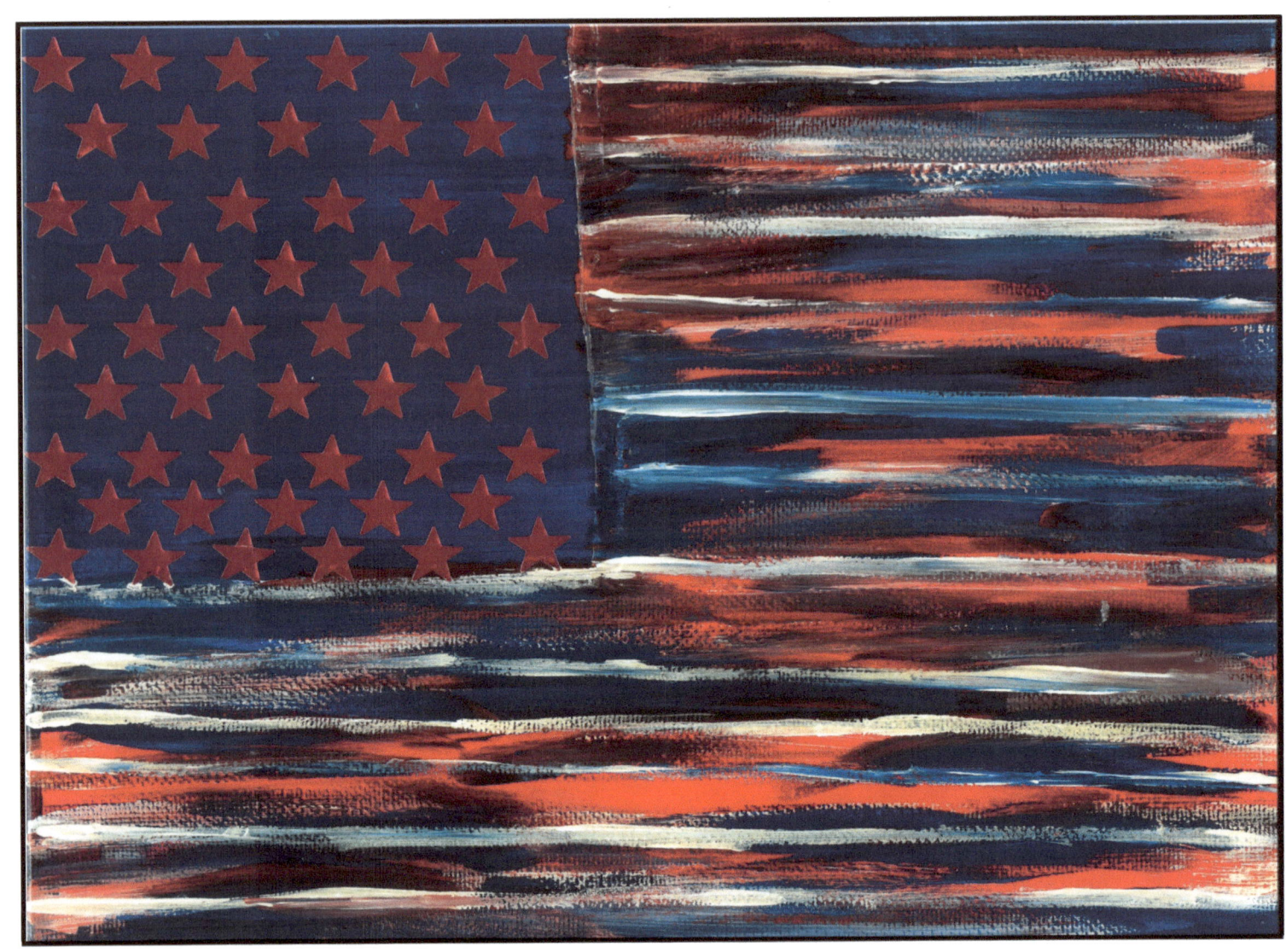

Liberty

11

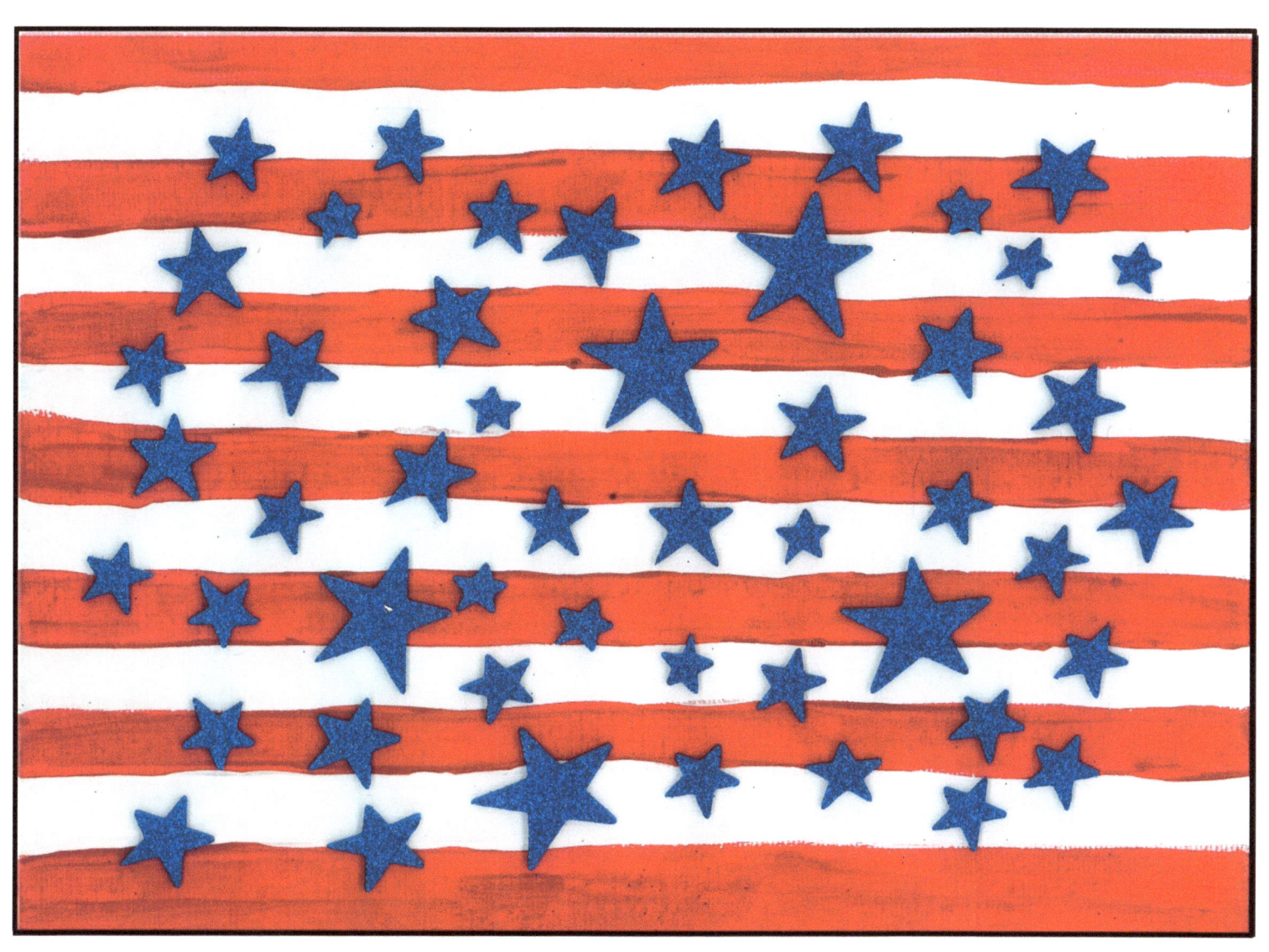

Freedom

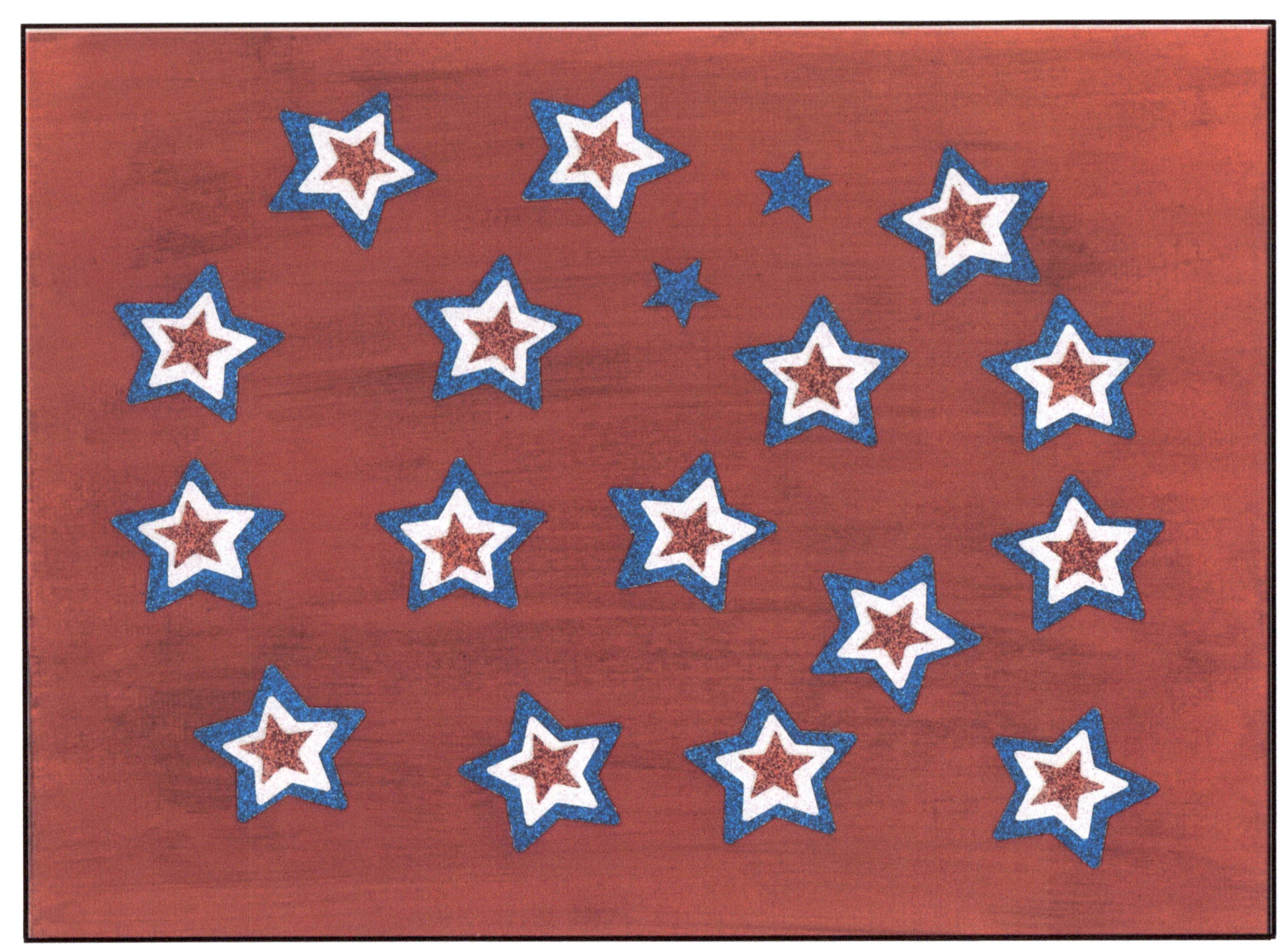

Law

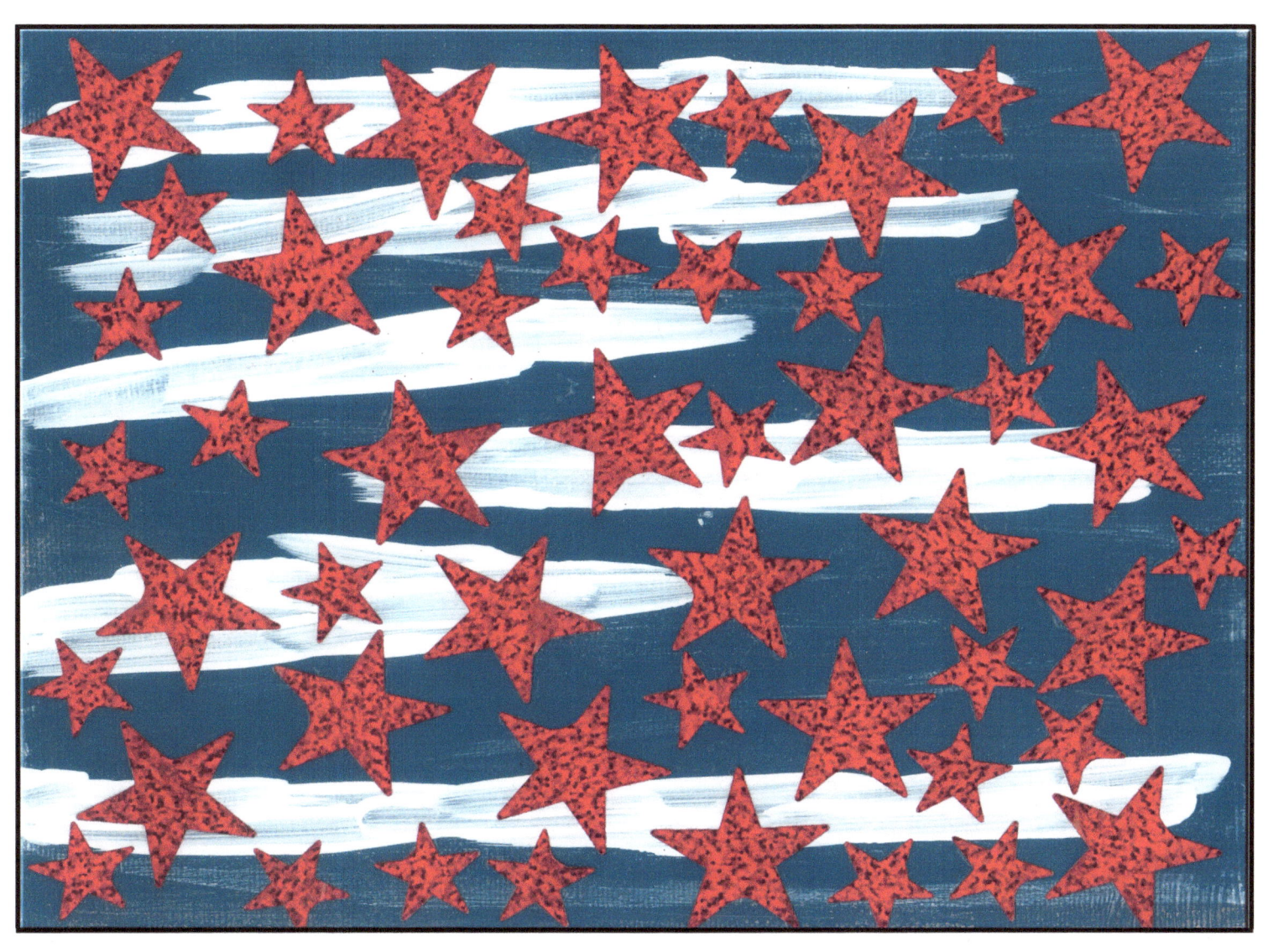

Justice

14

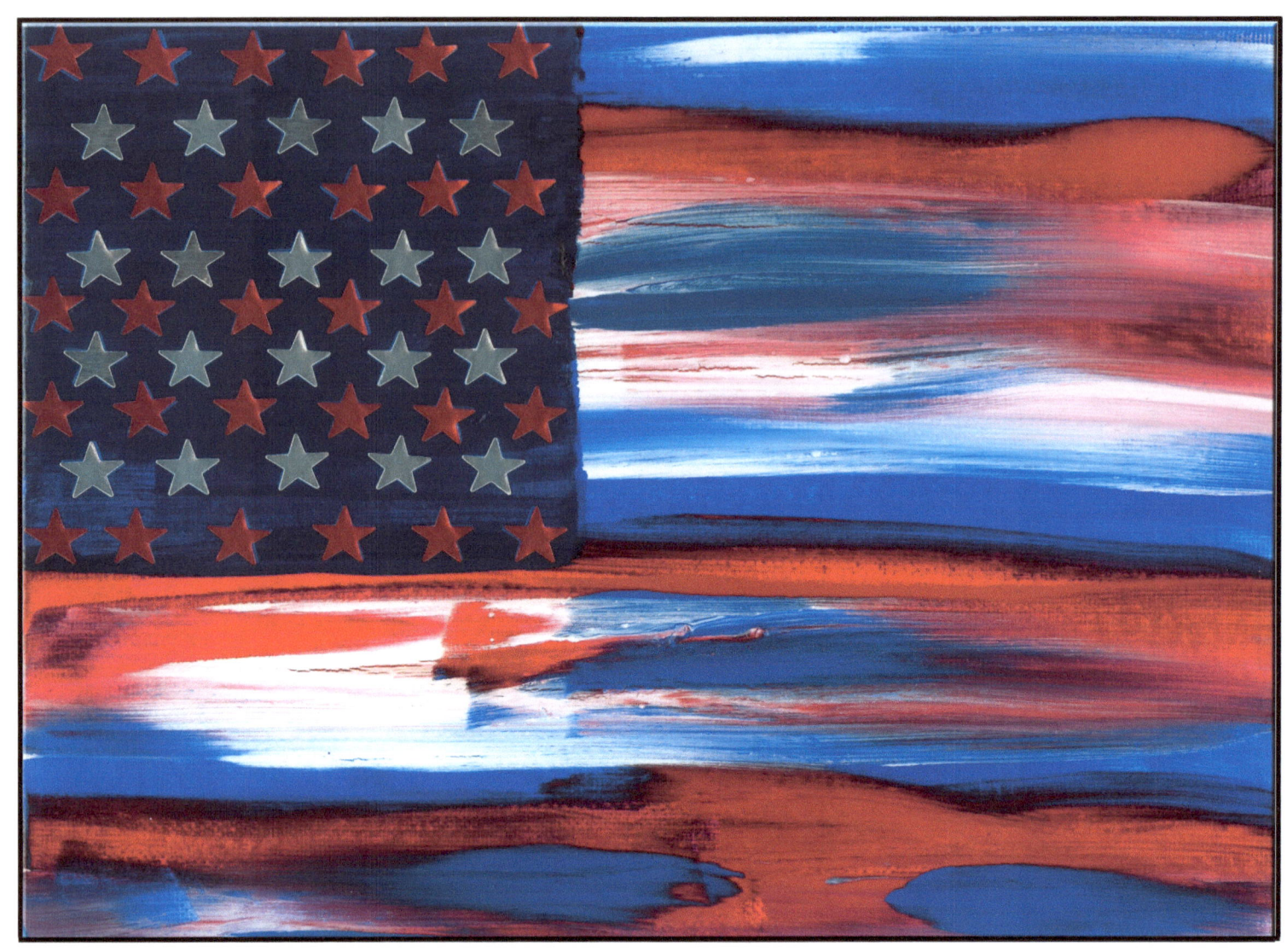

Service

15

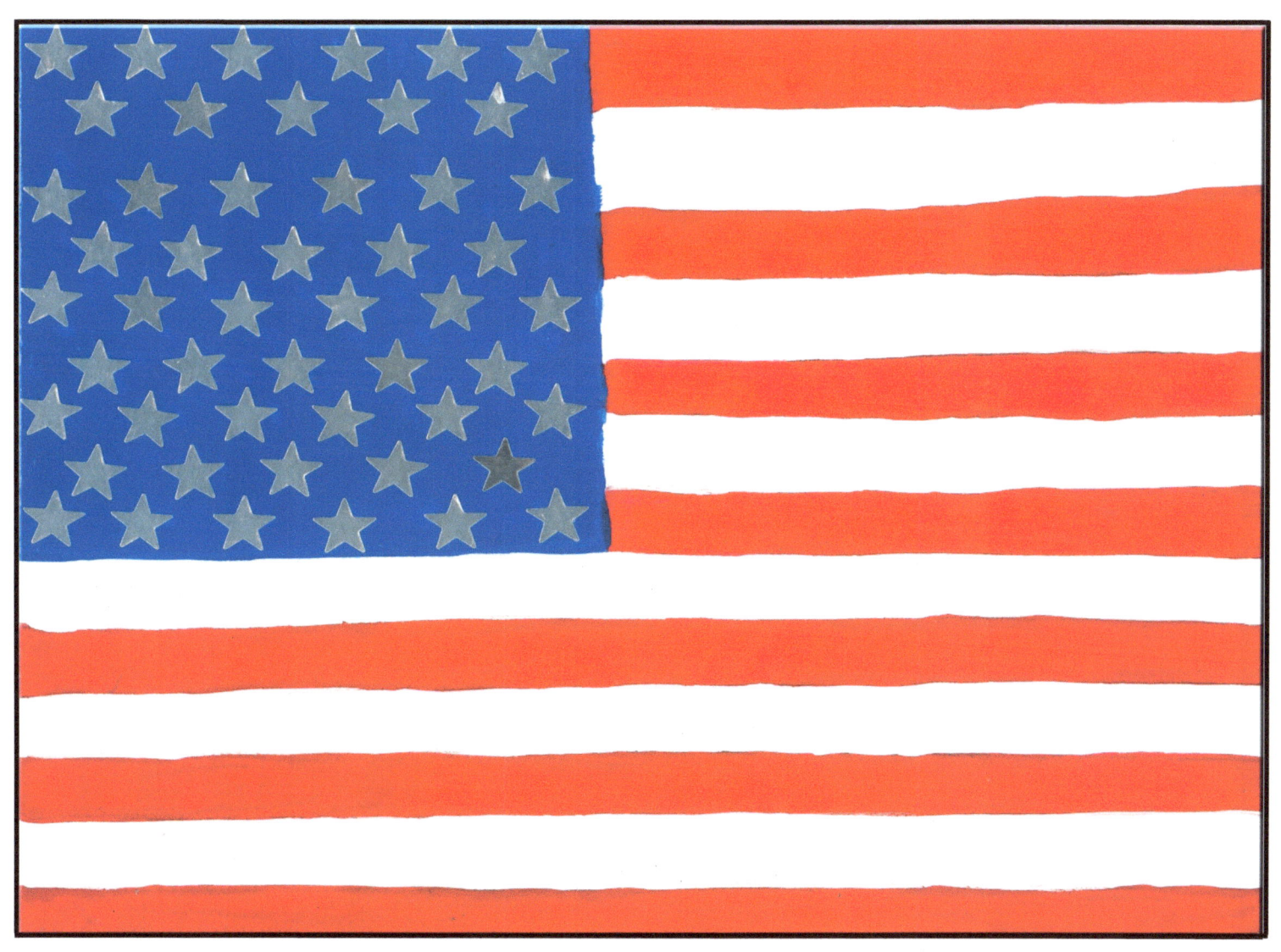

Protection

16

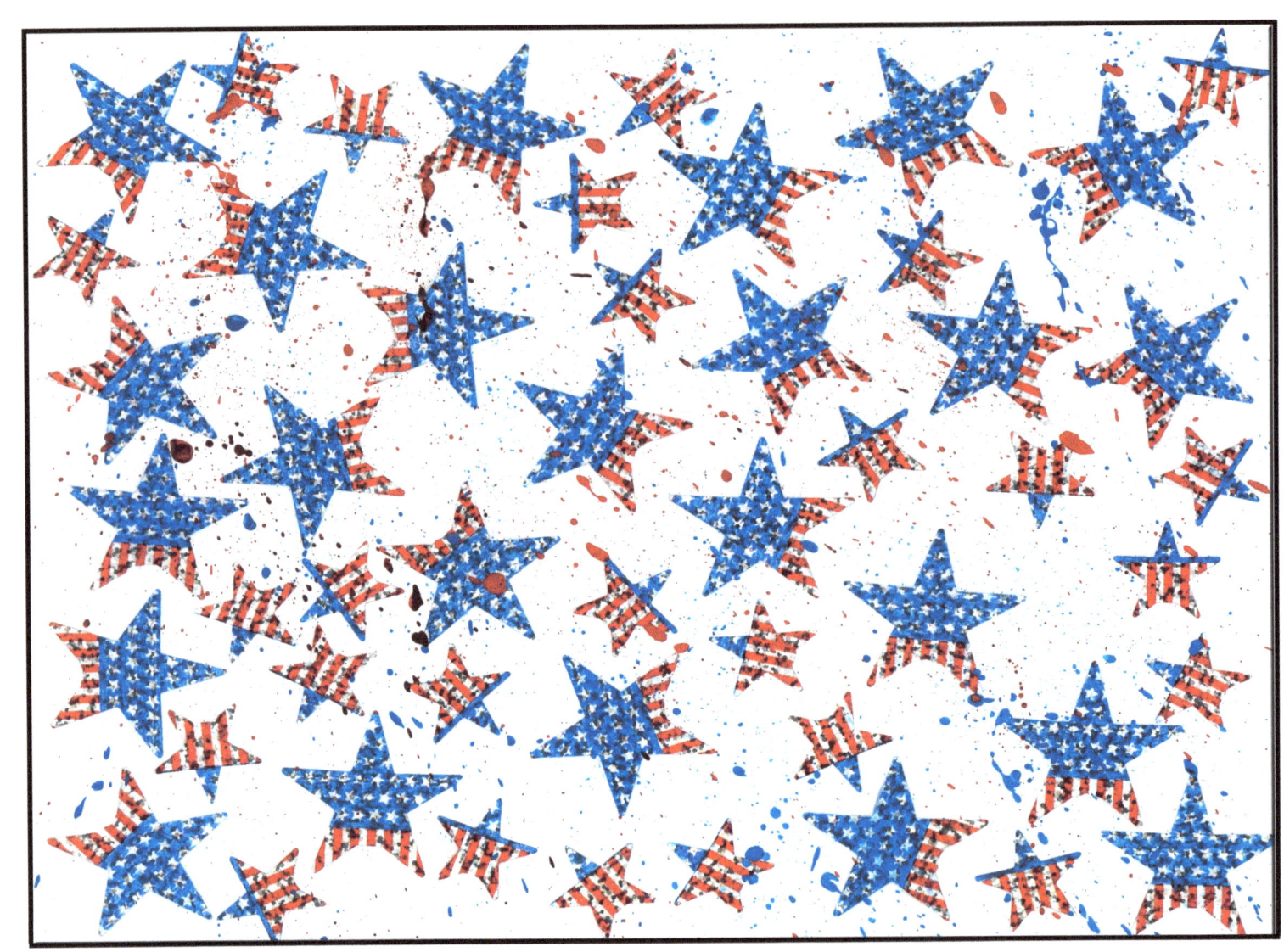

Community

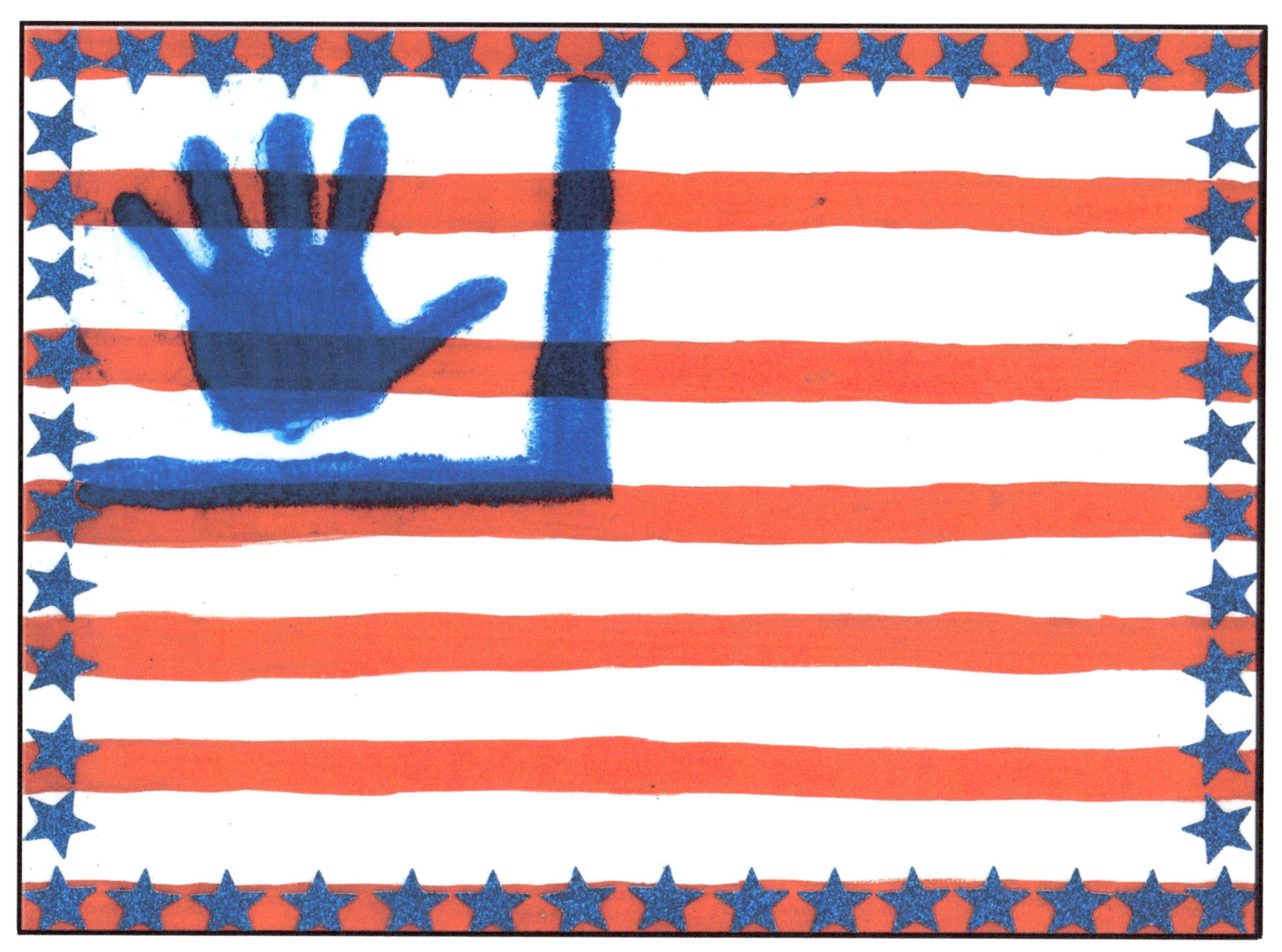

Family

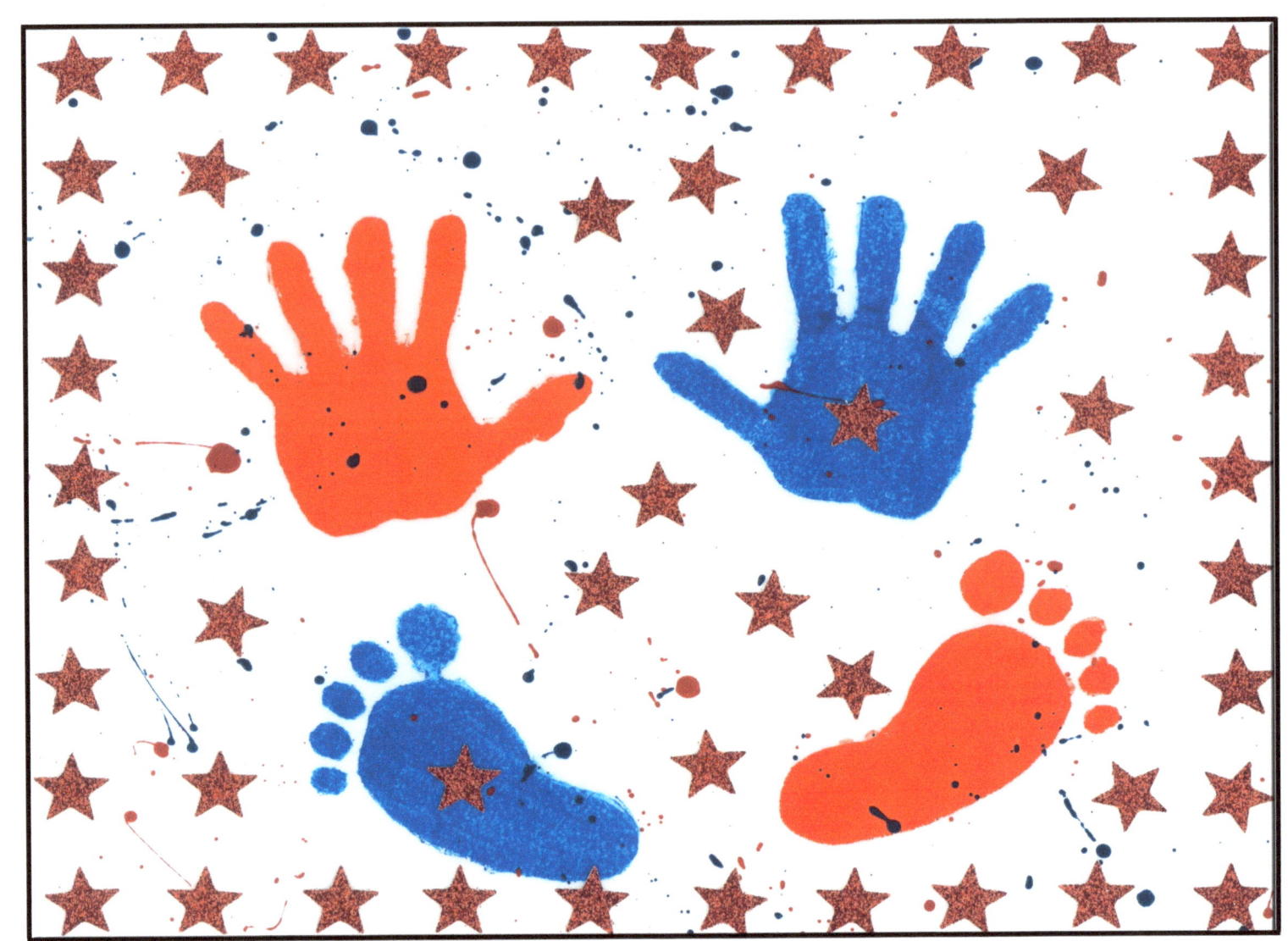
Sacrifice

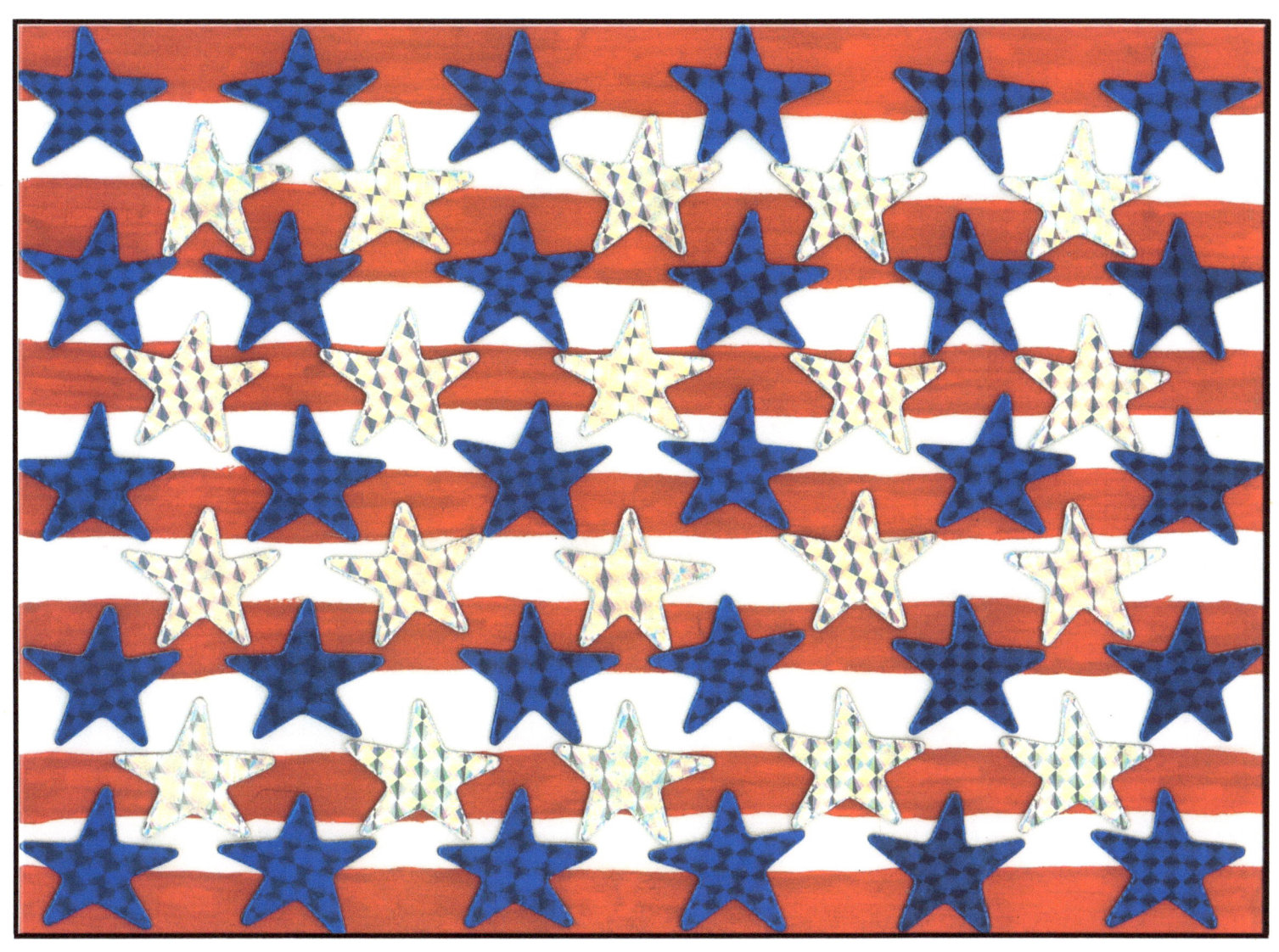

Honor

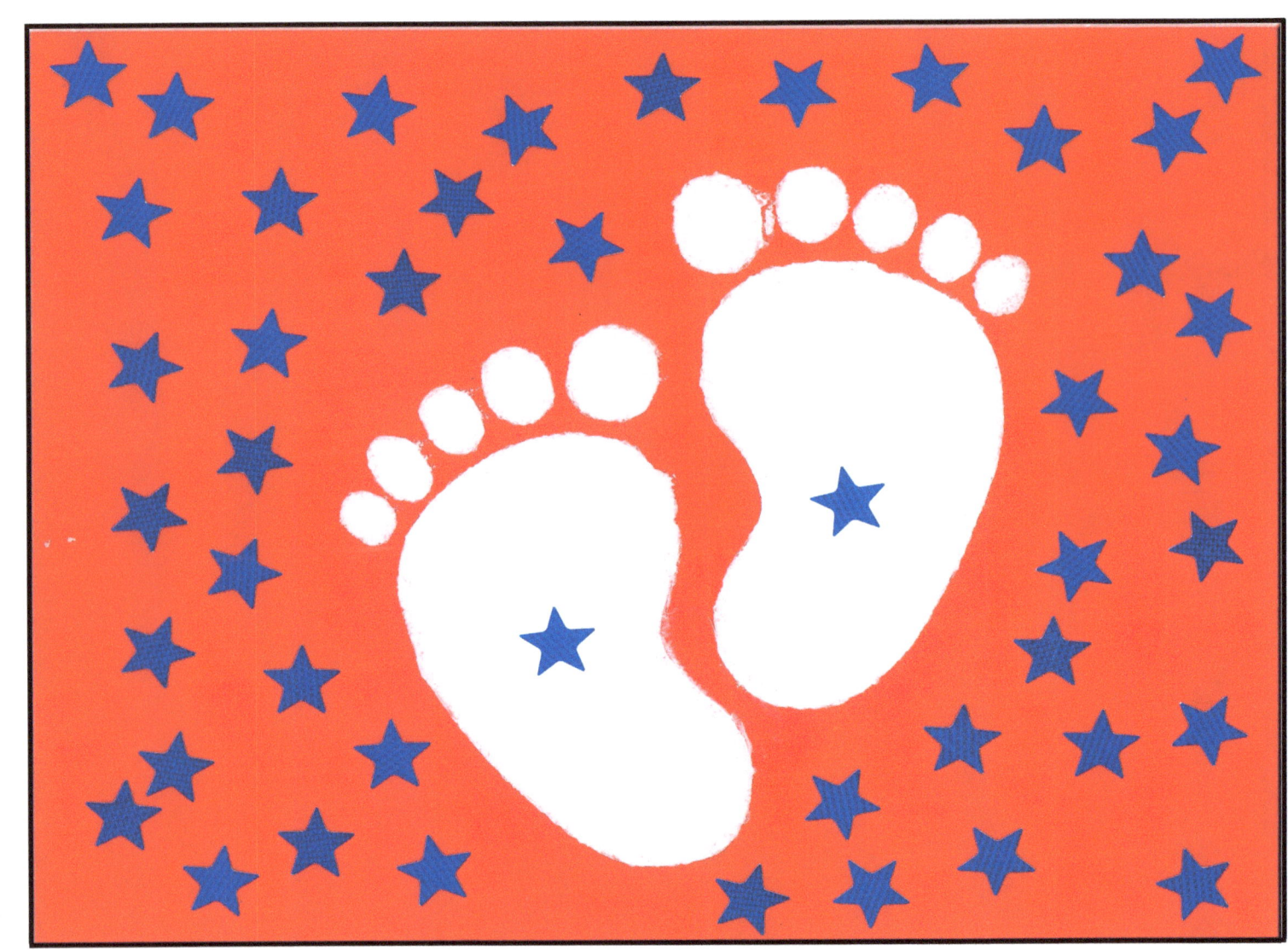

Heroes

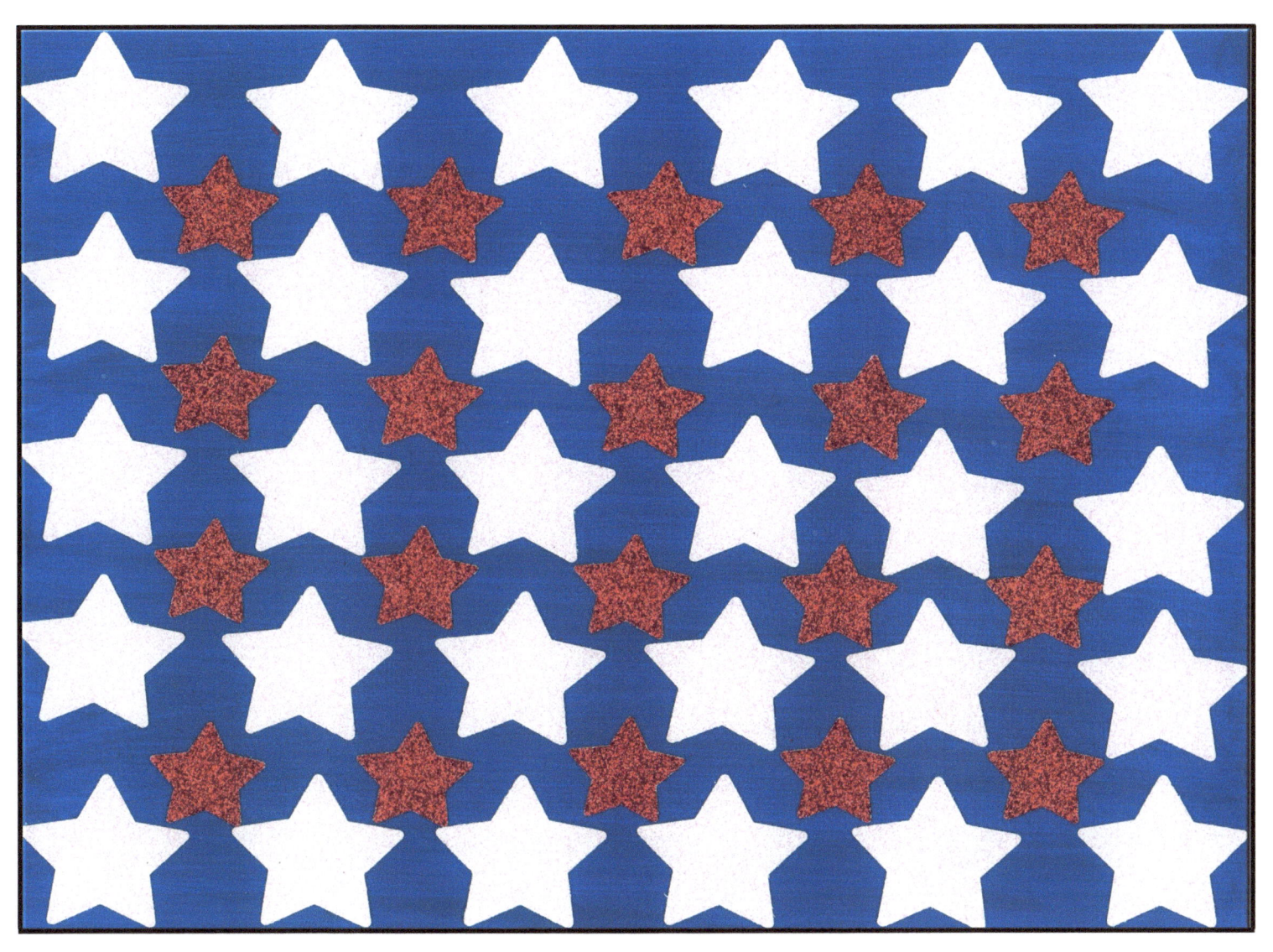

Courage

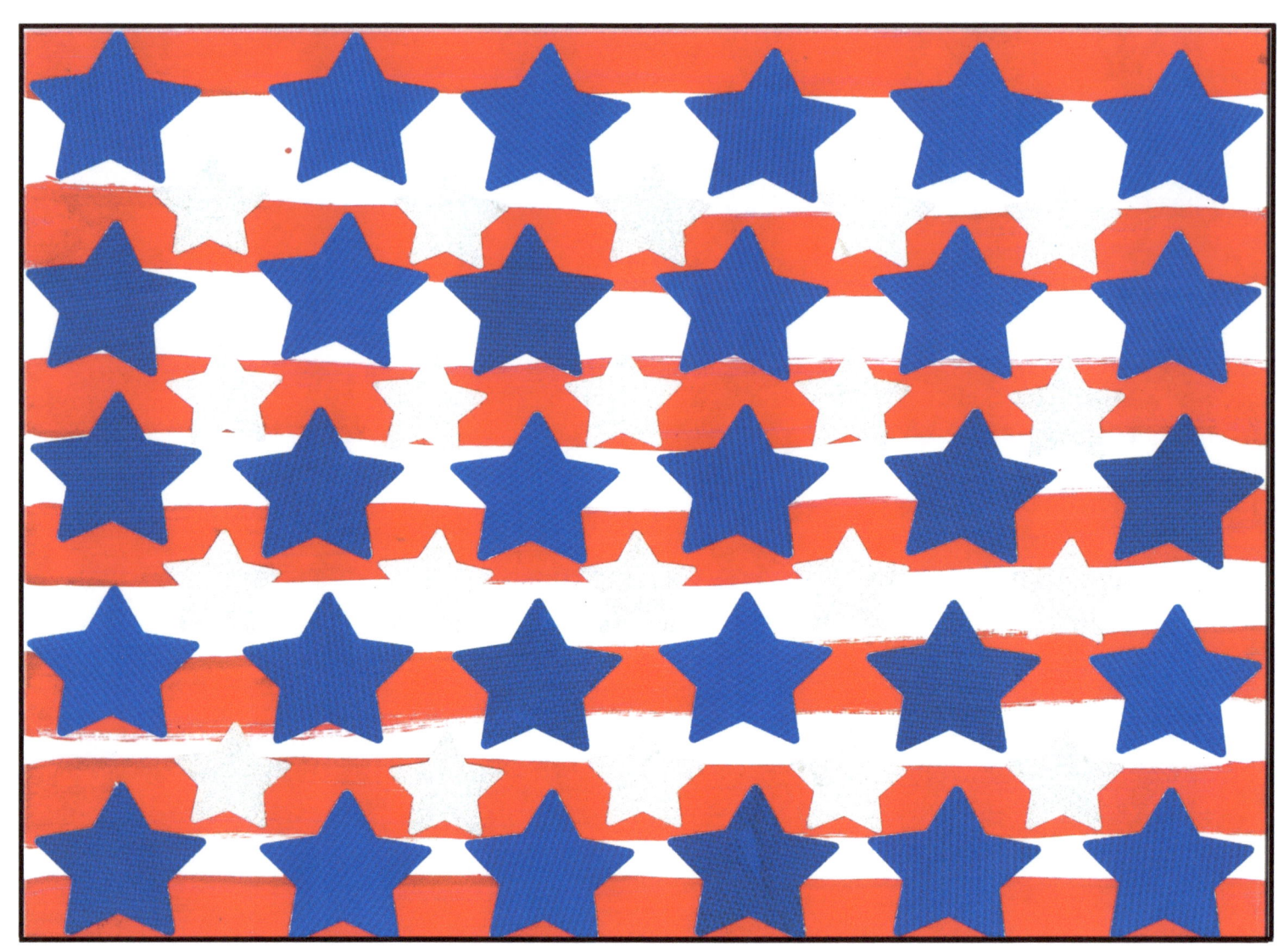

Strength

23

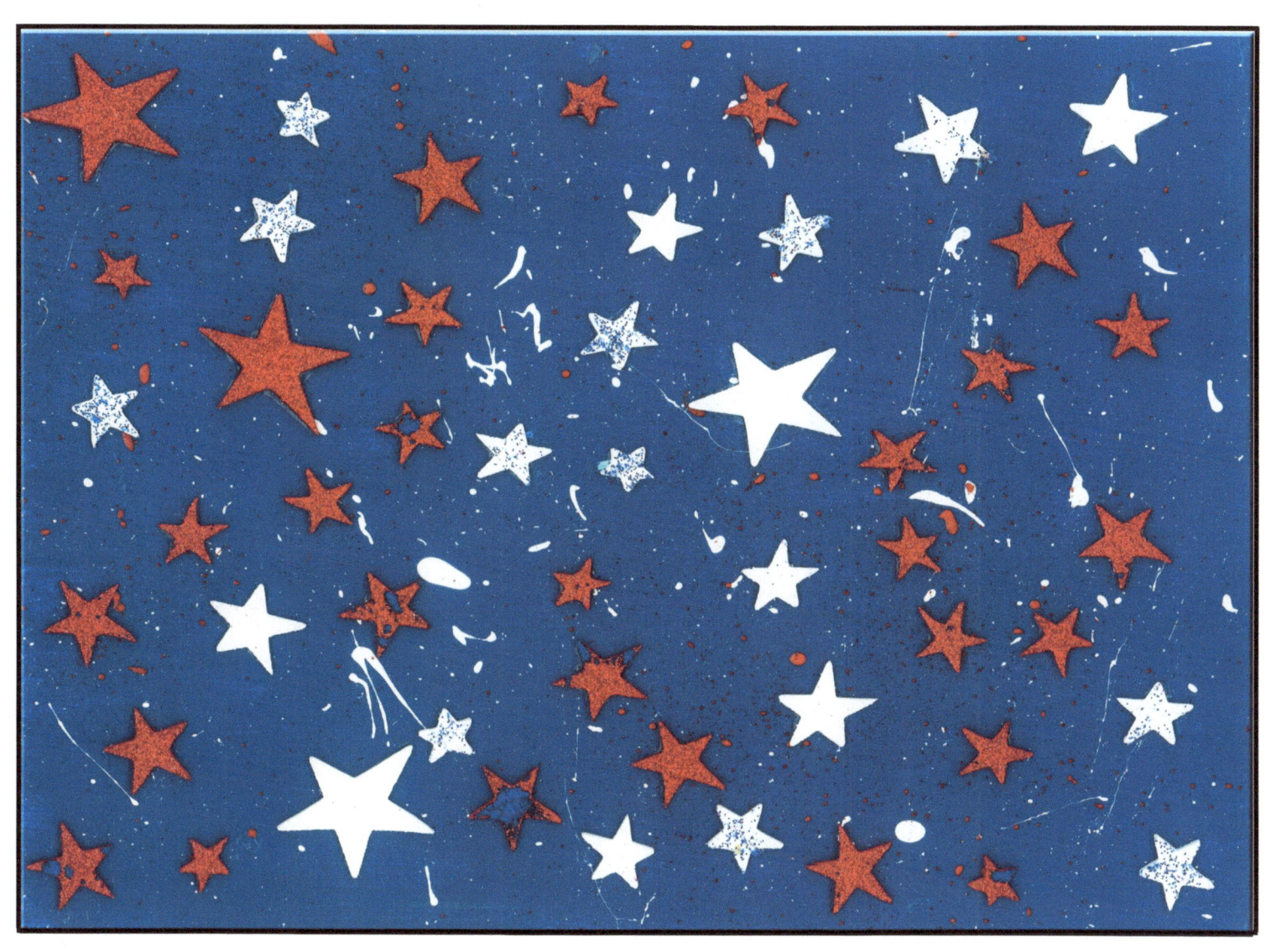

Safety

24

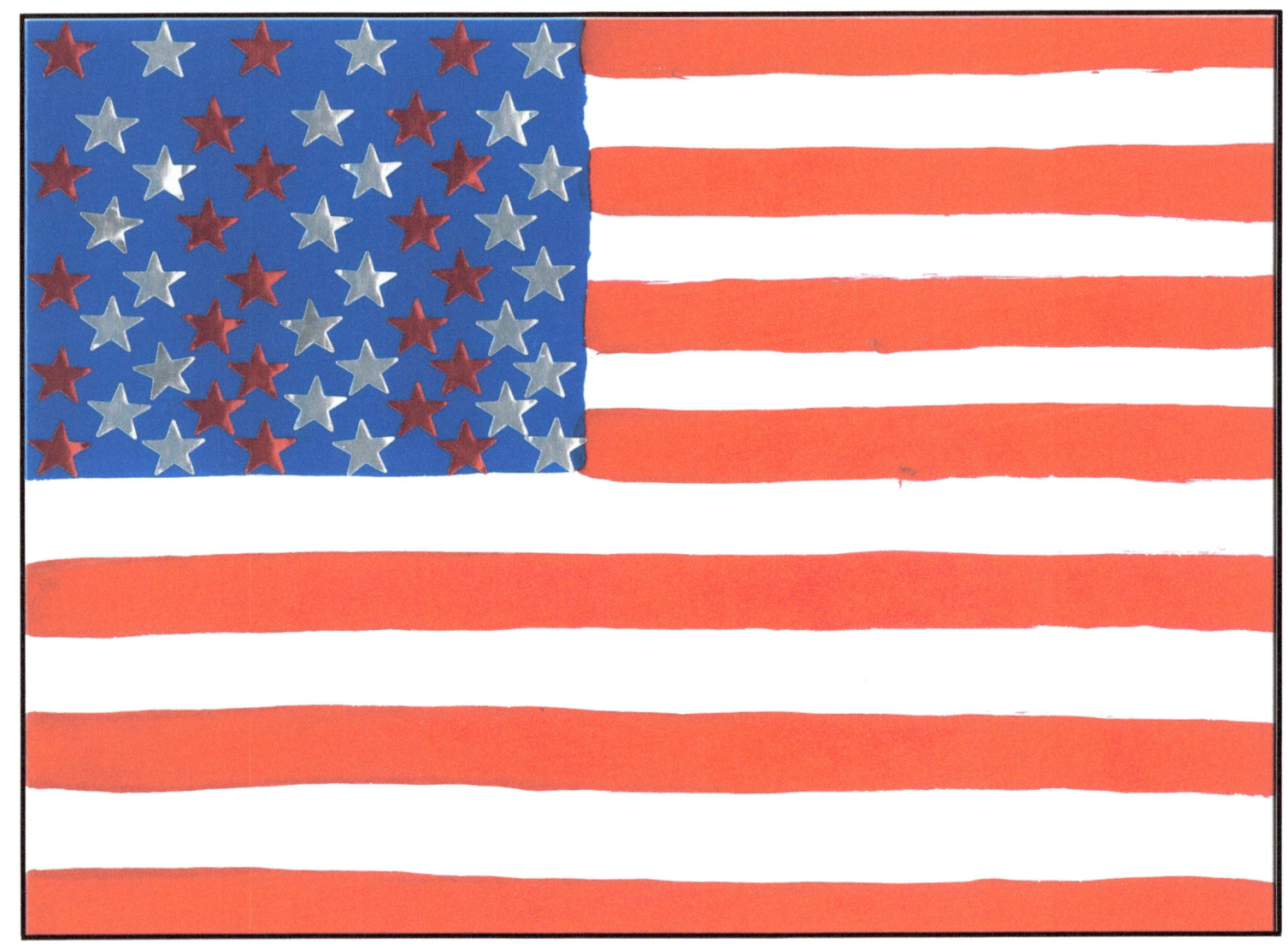

Respect

25

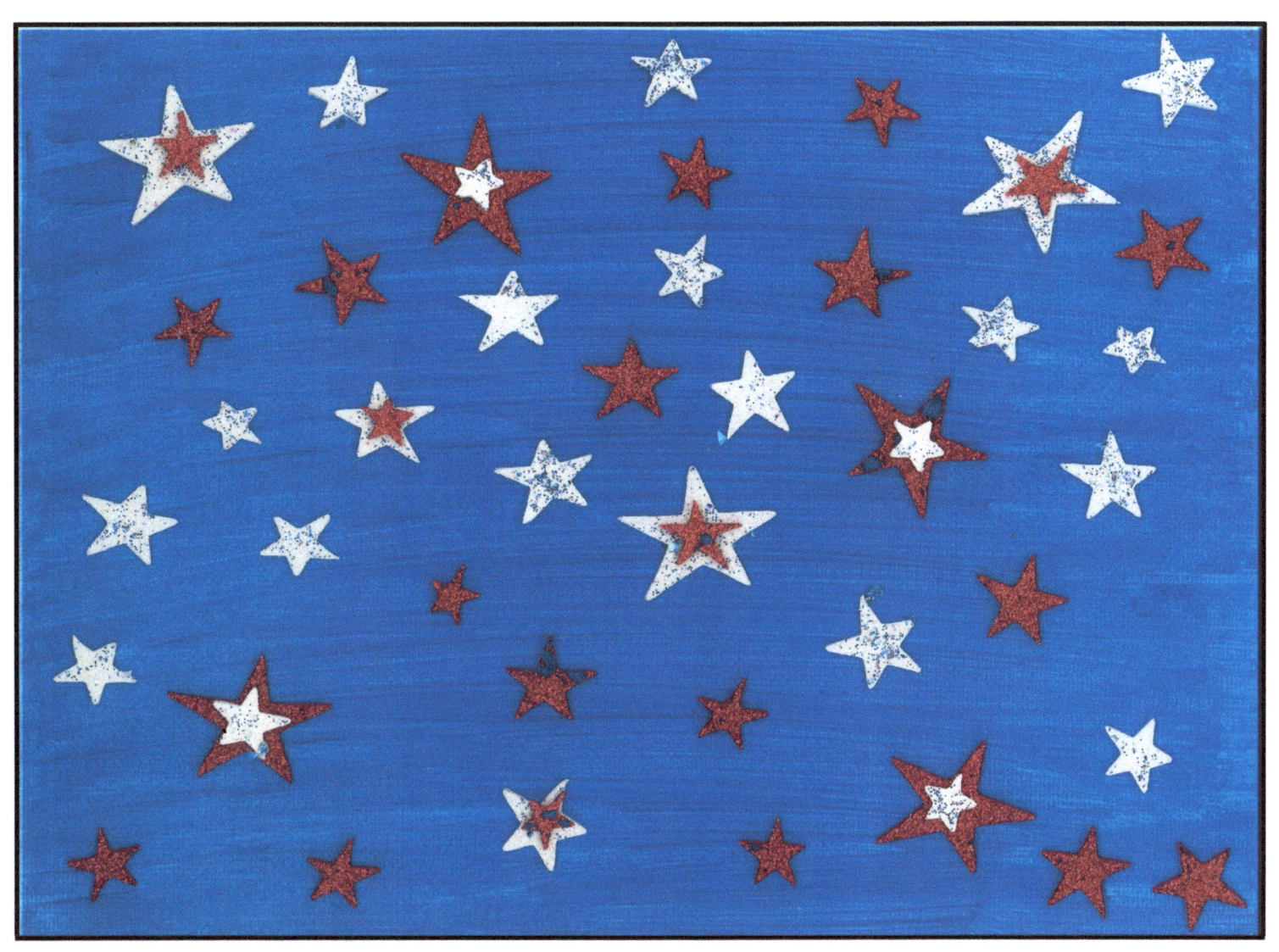

Trust

26

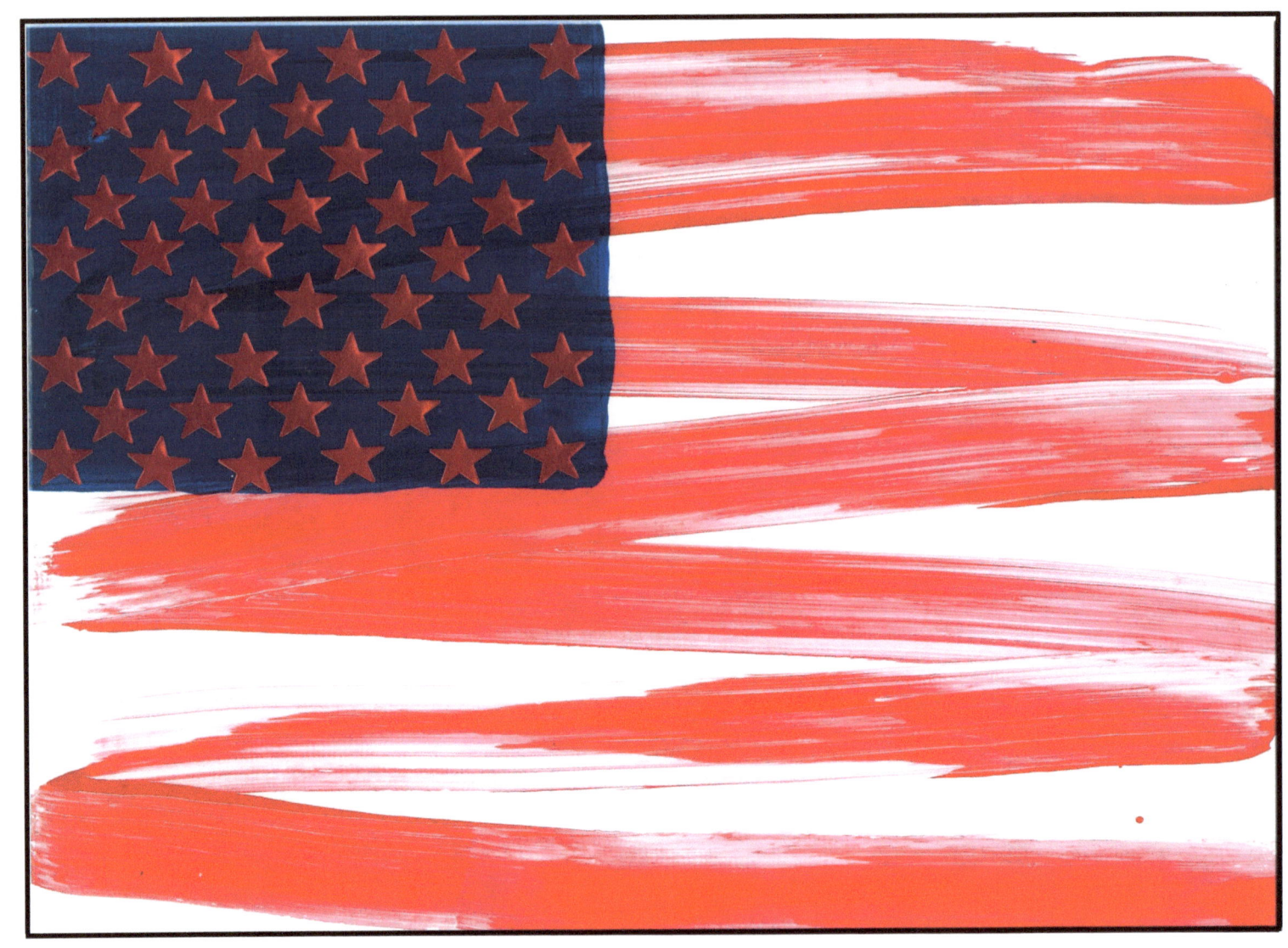

Leadership

27

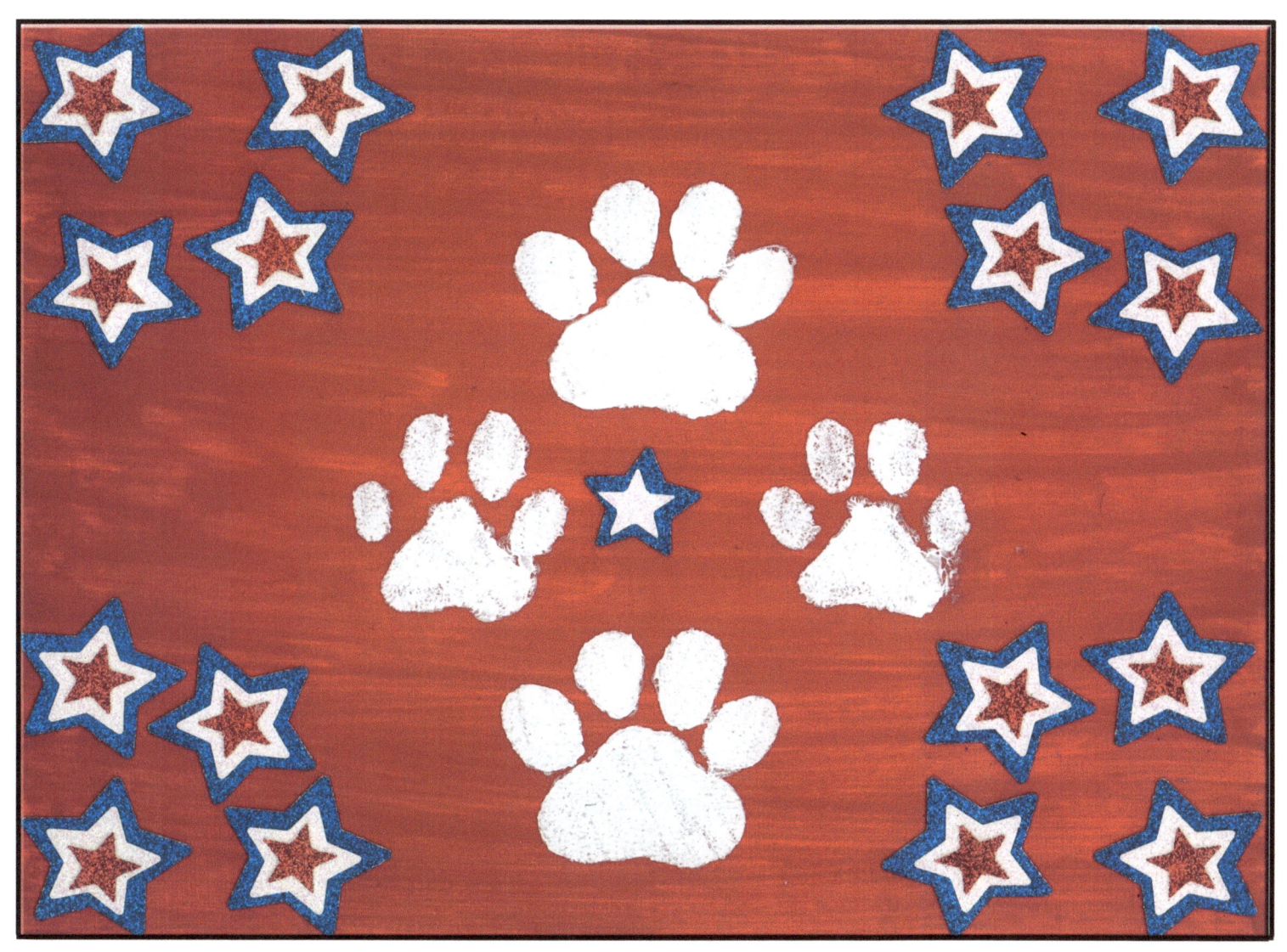

Teamwork

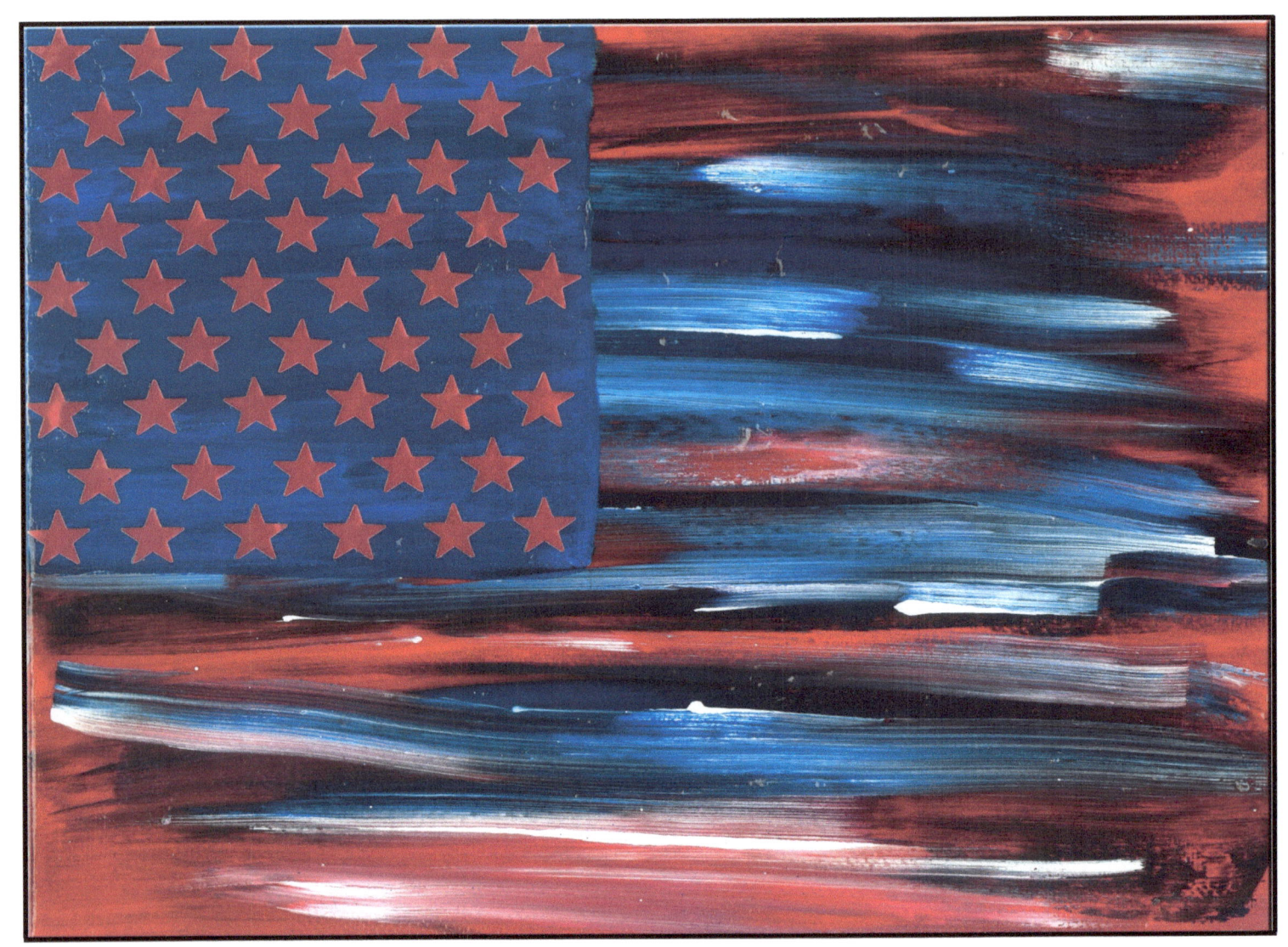

Loyalty

29

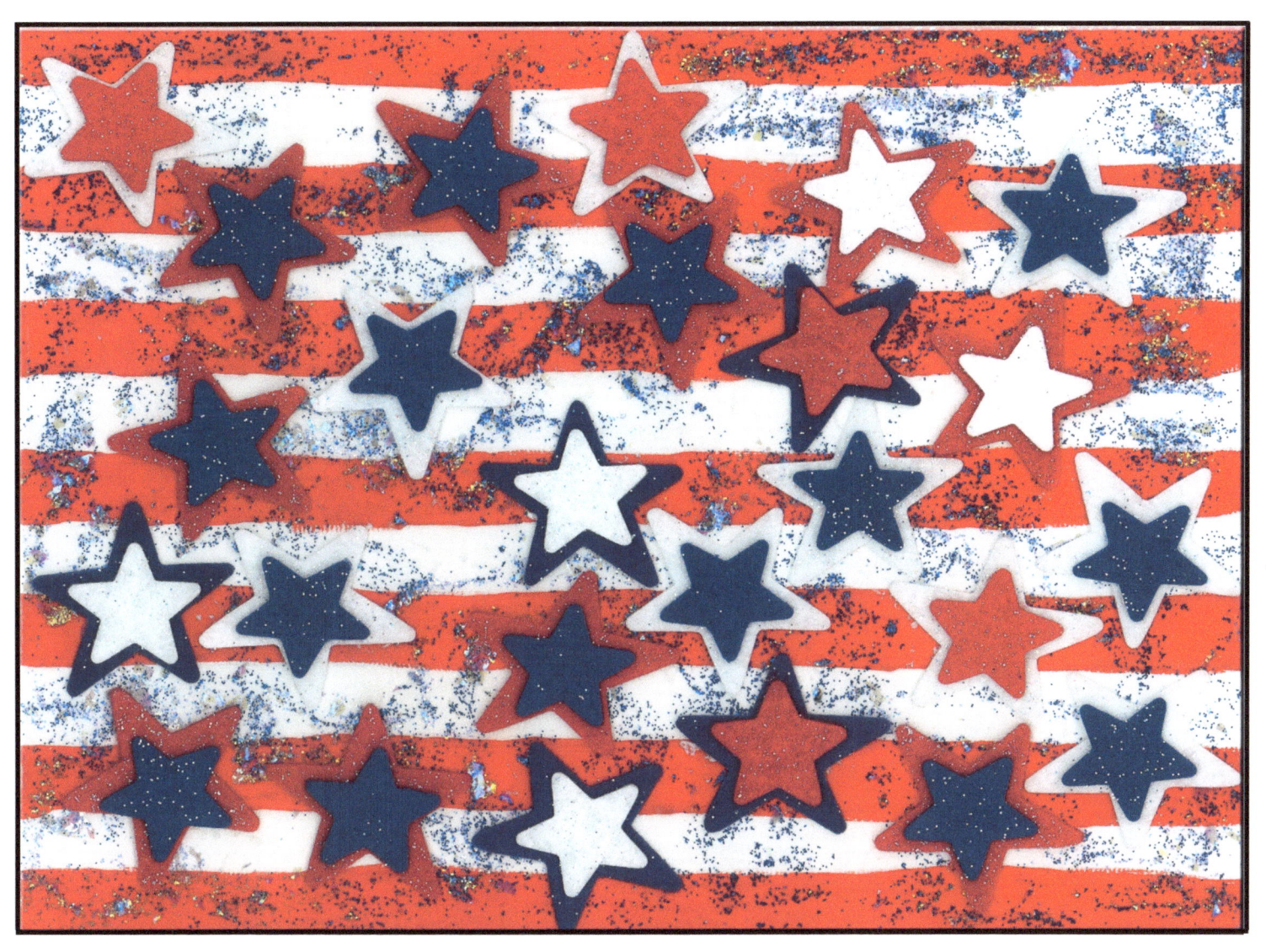

Honesty

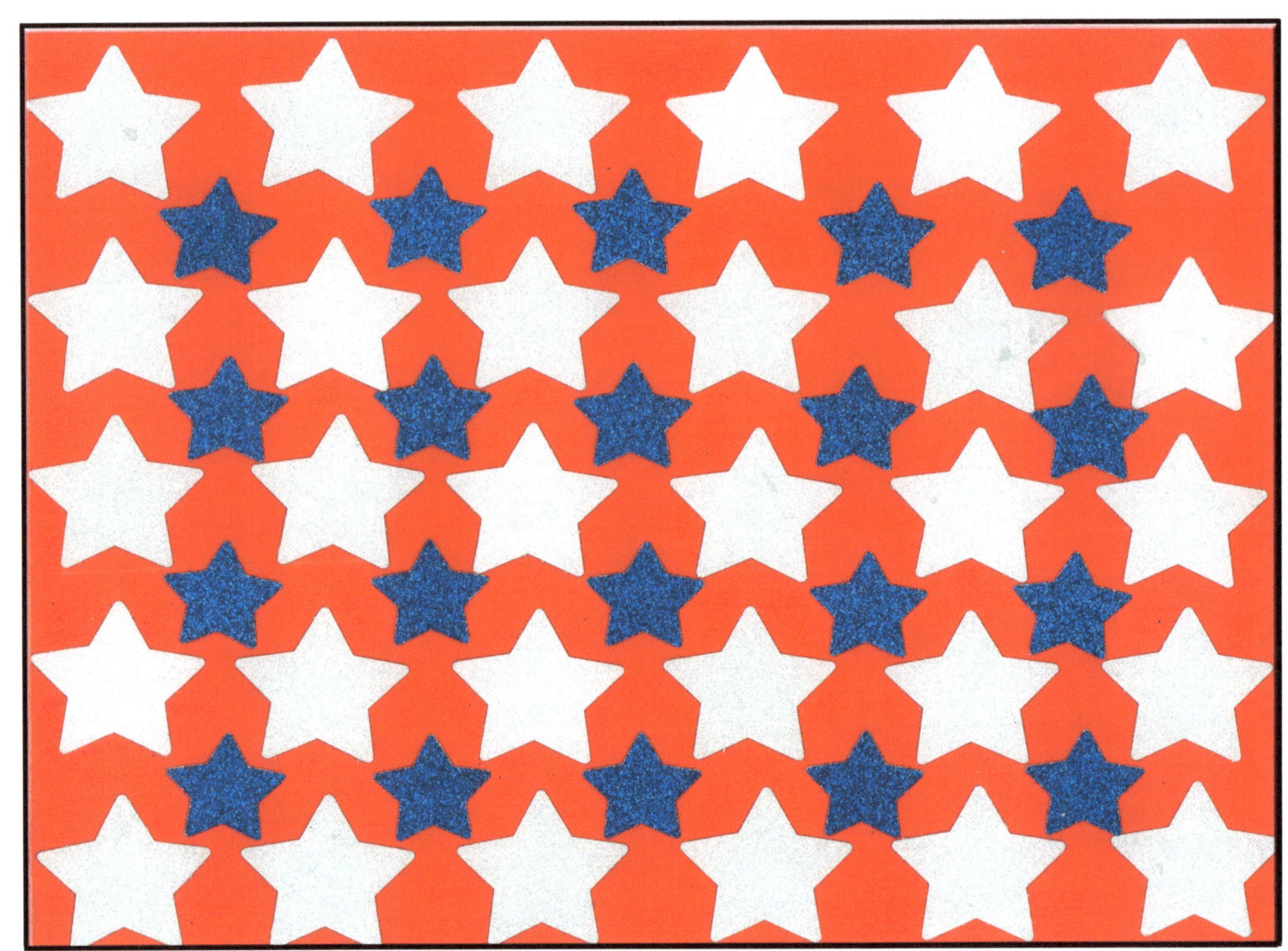

Dedication

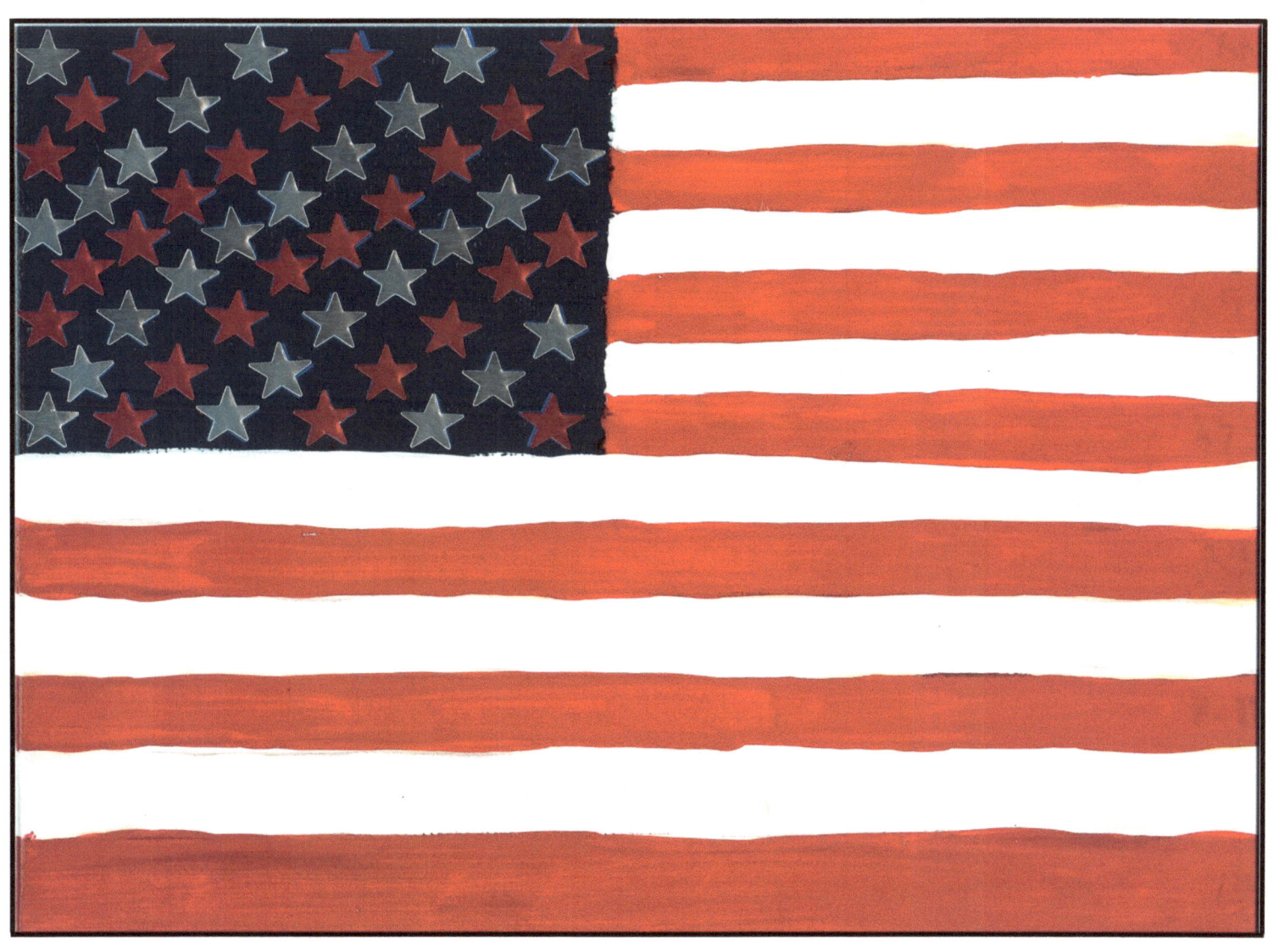

Discipline

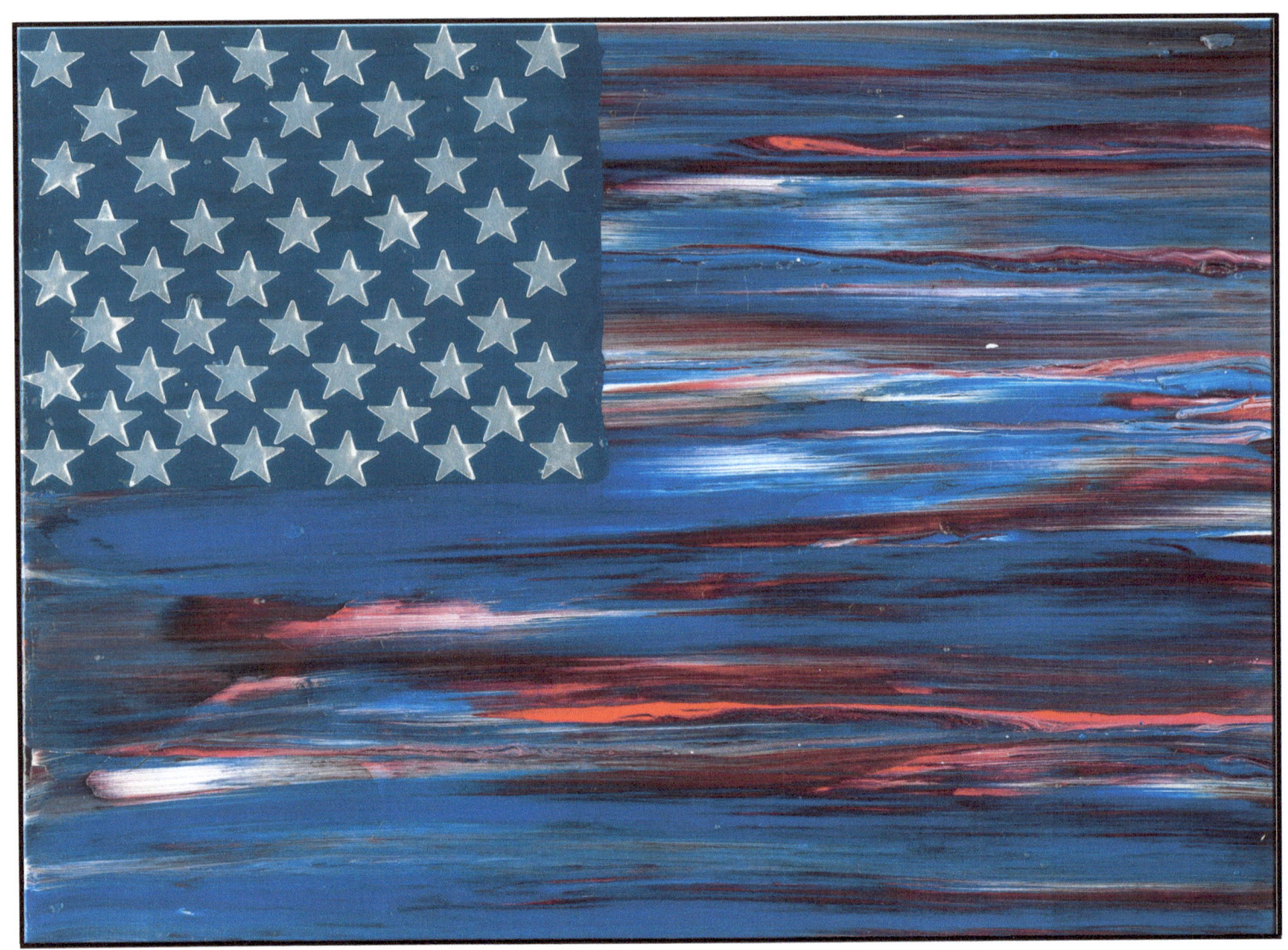

Persistence

33

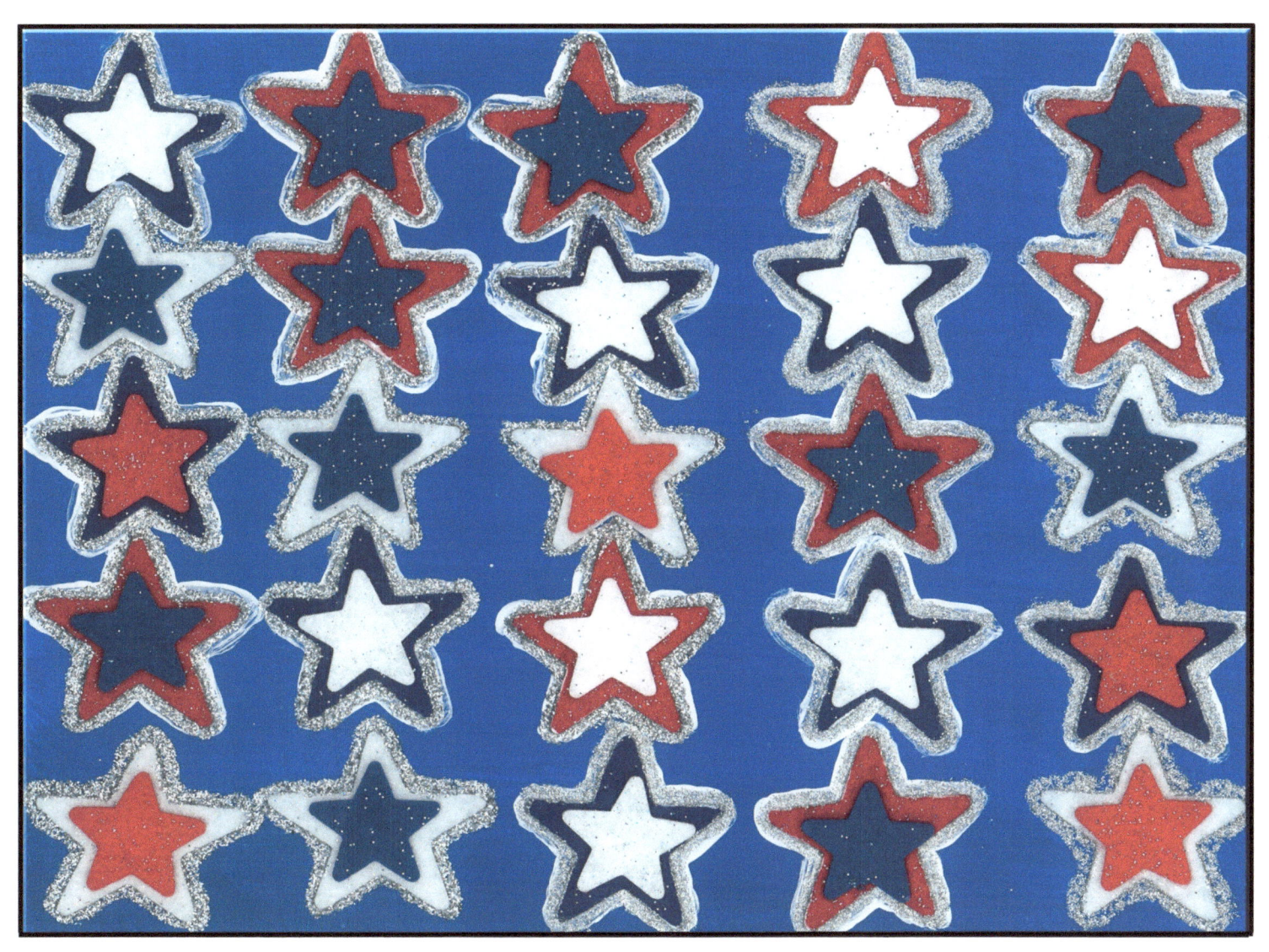

Advocate

34

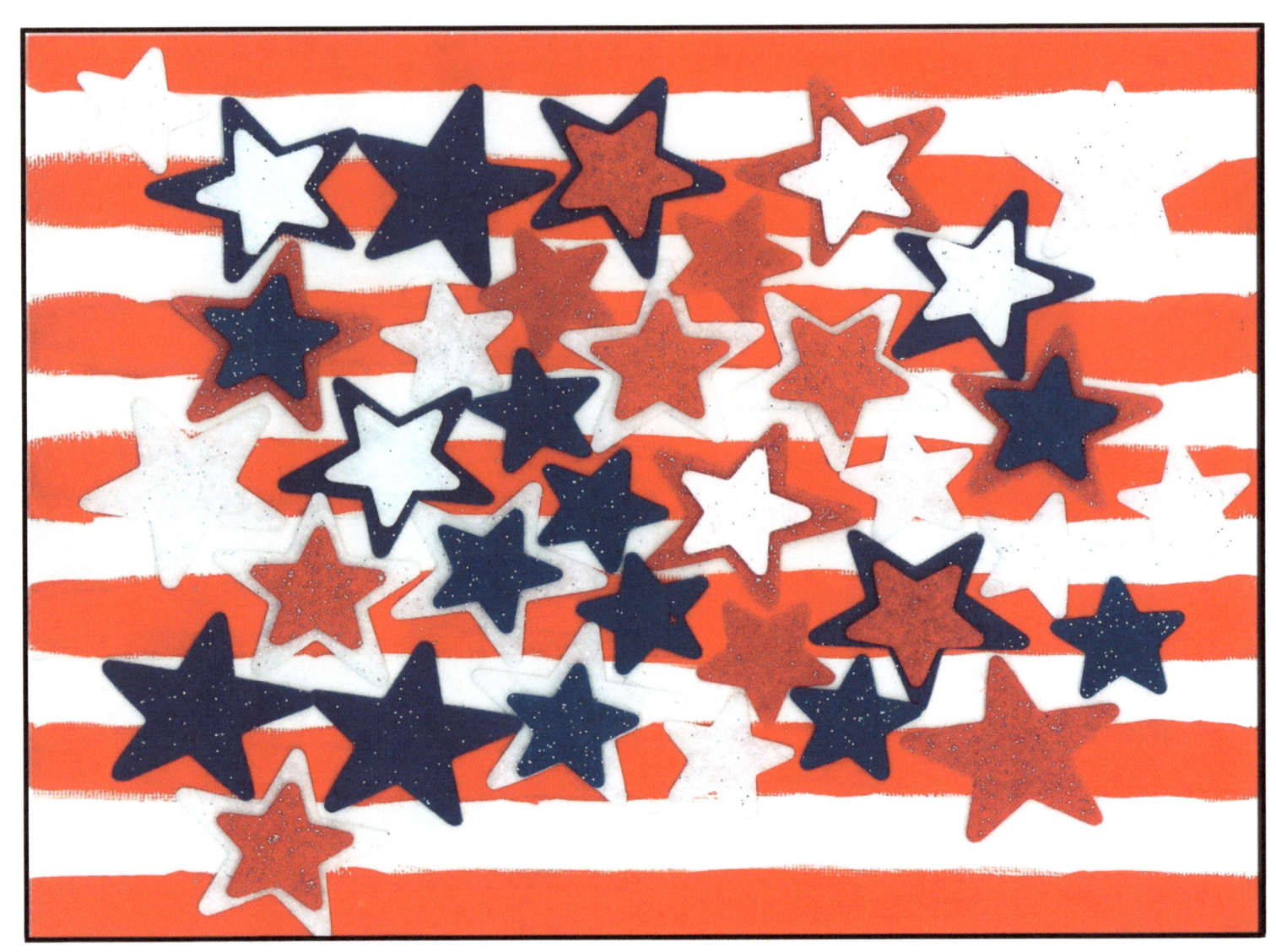

Intelligent

35

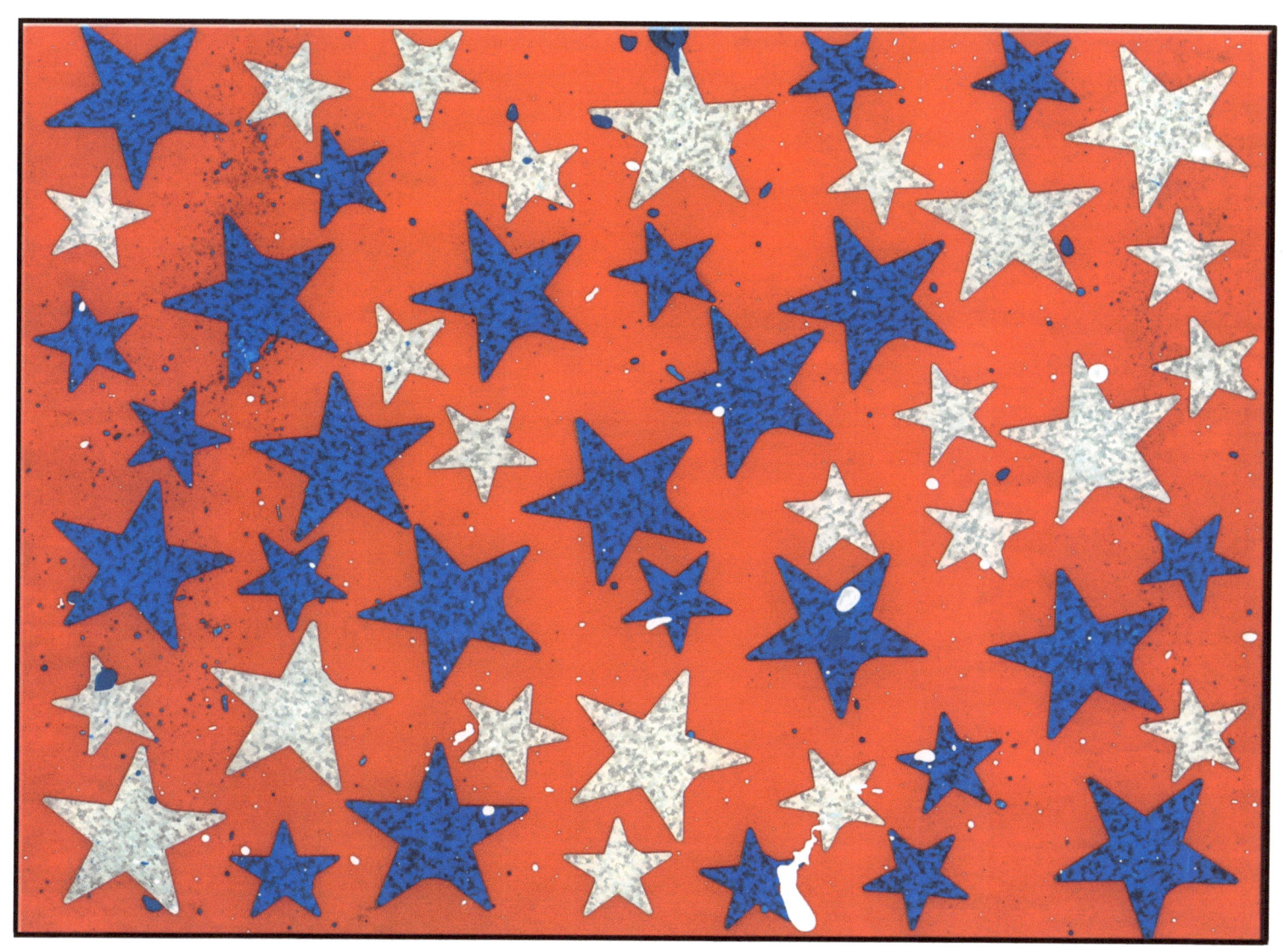

Good Listener

36

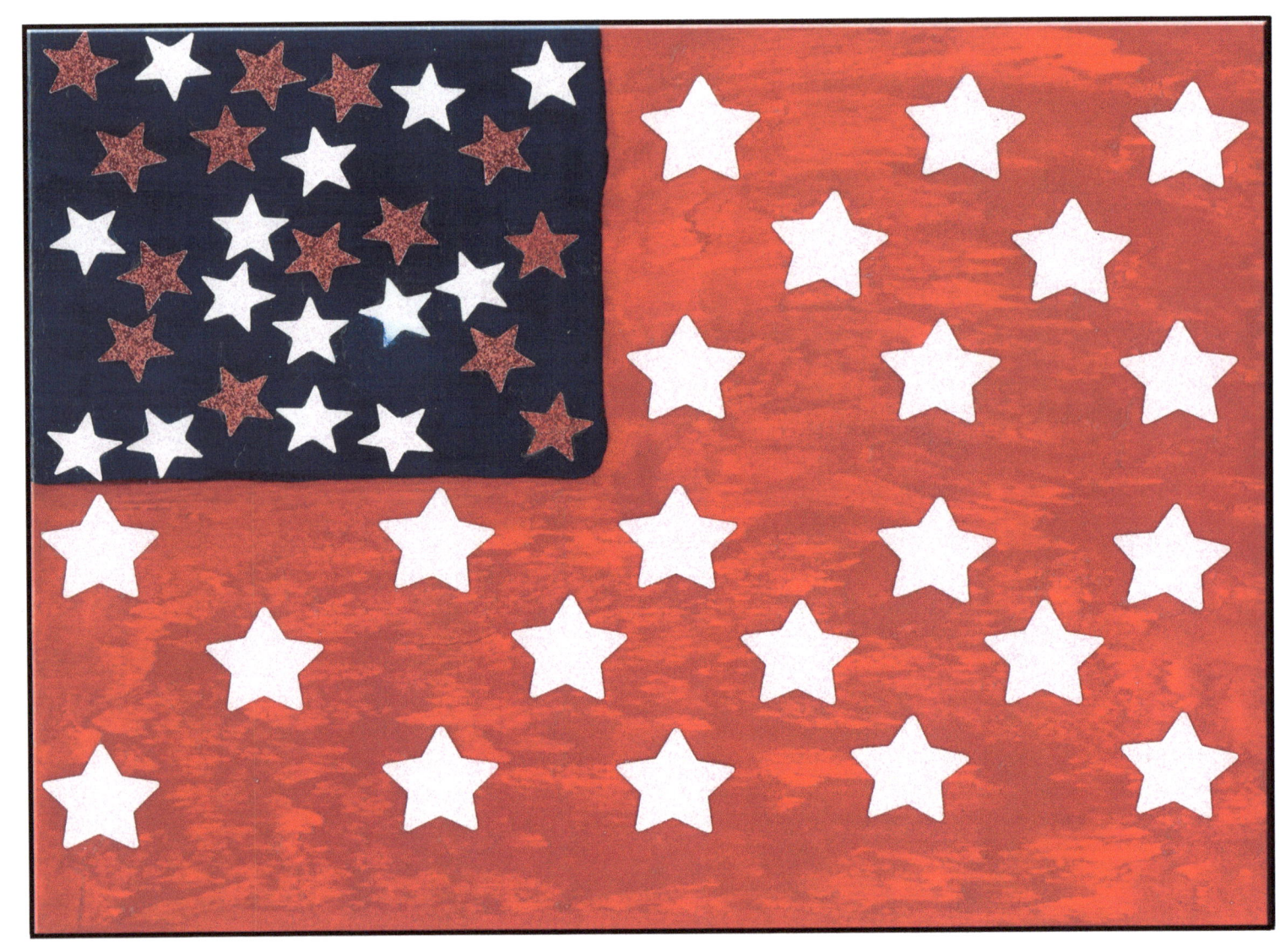

Integrity

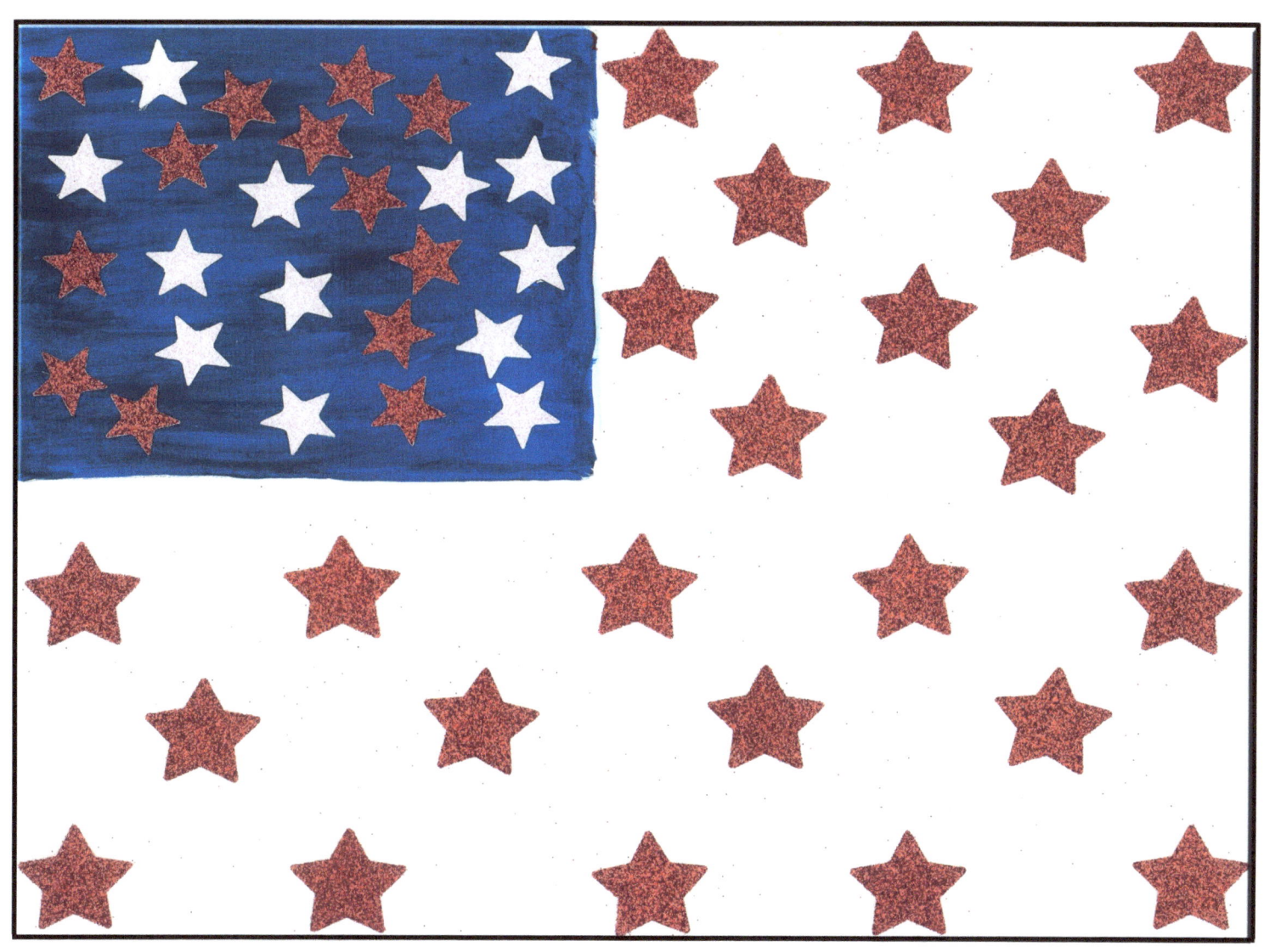

Punctuality

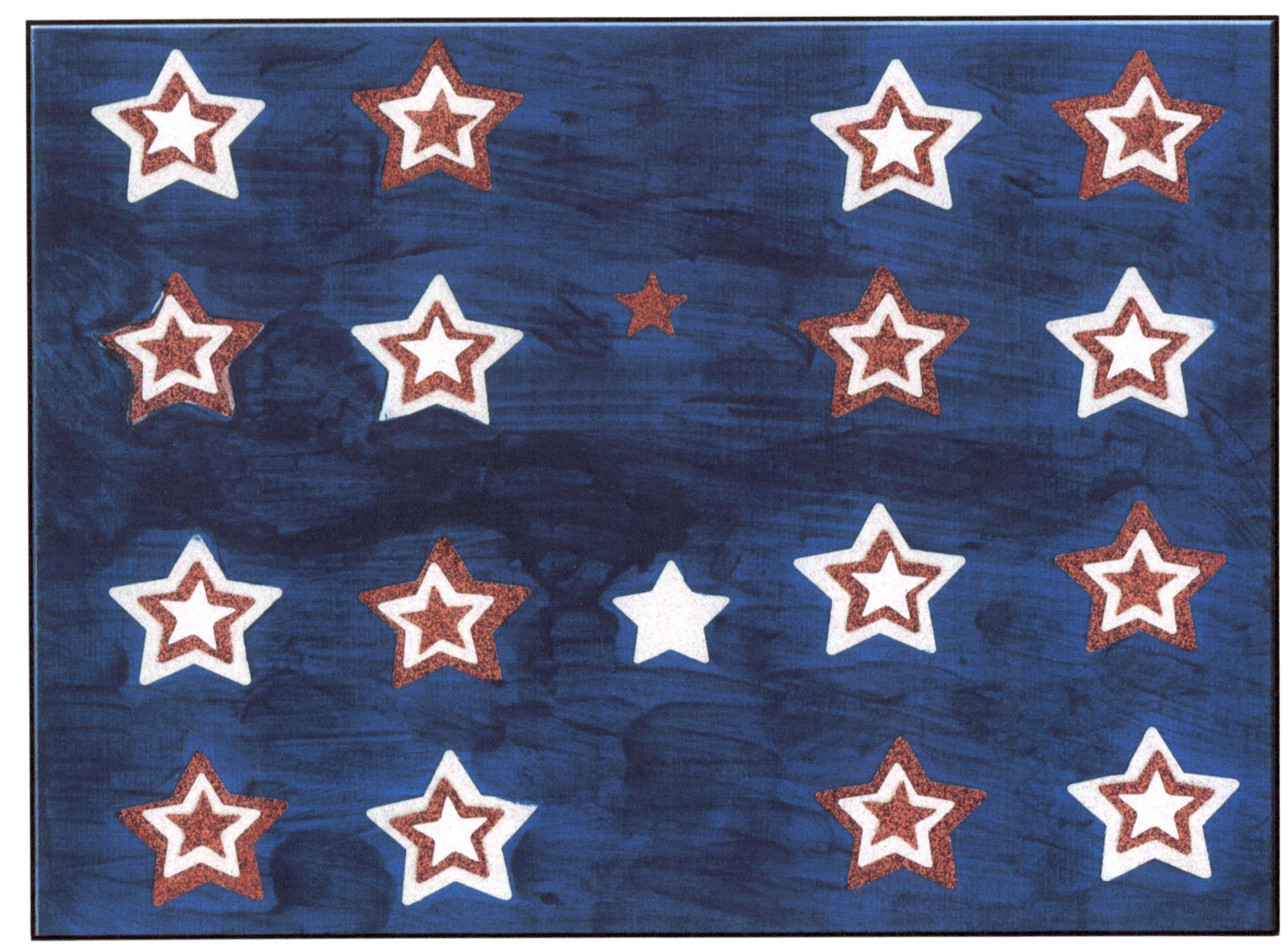

Responsibility

39

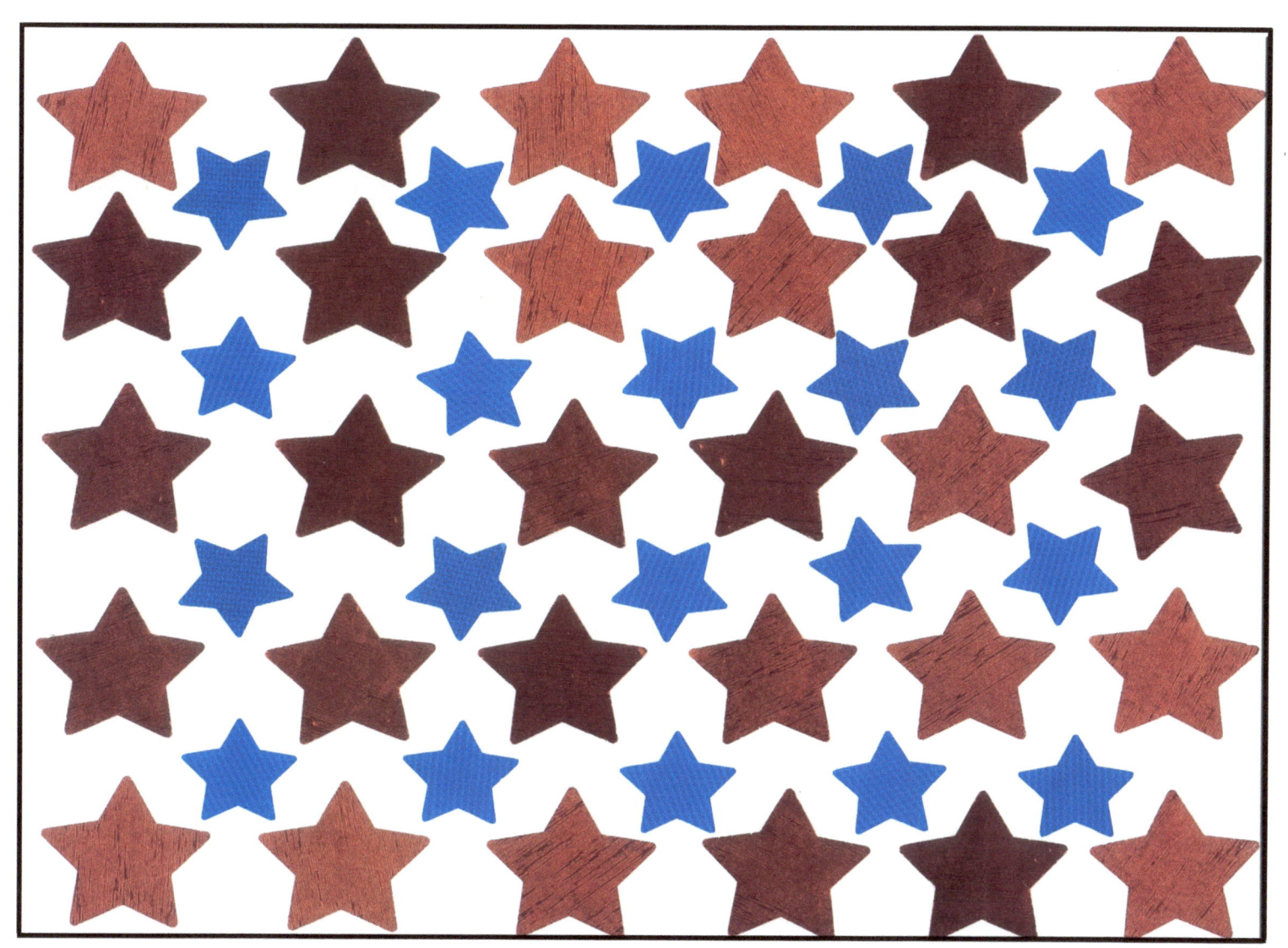

Accountability

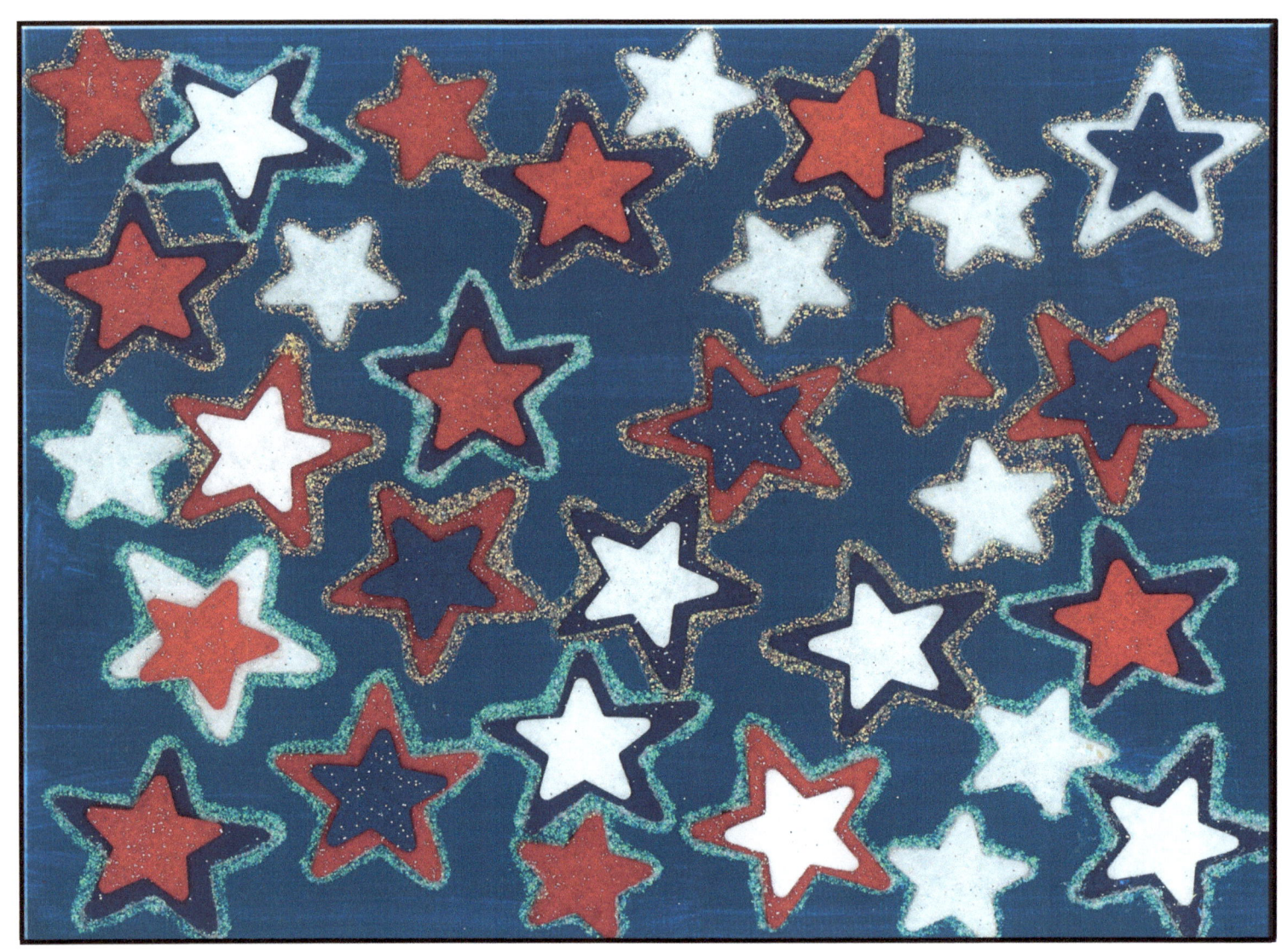

Flexibility

41

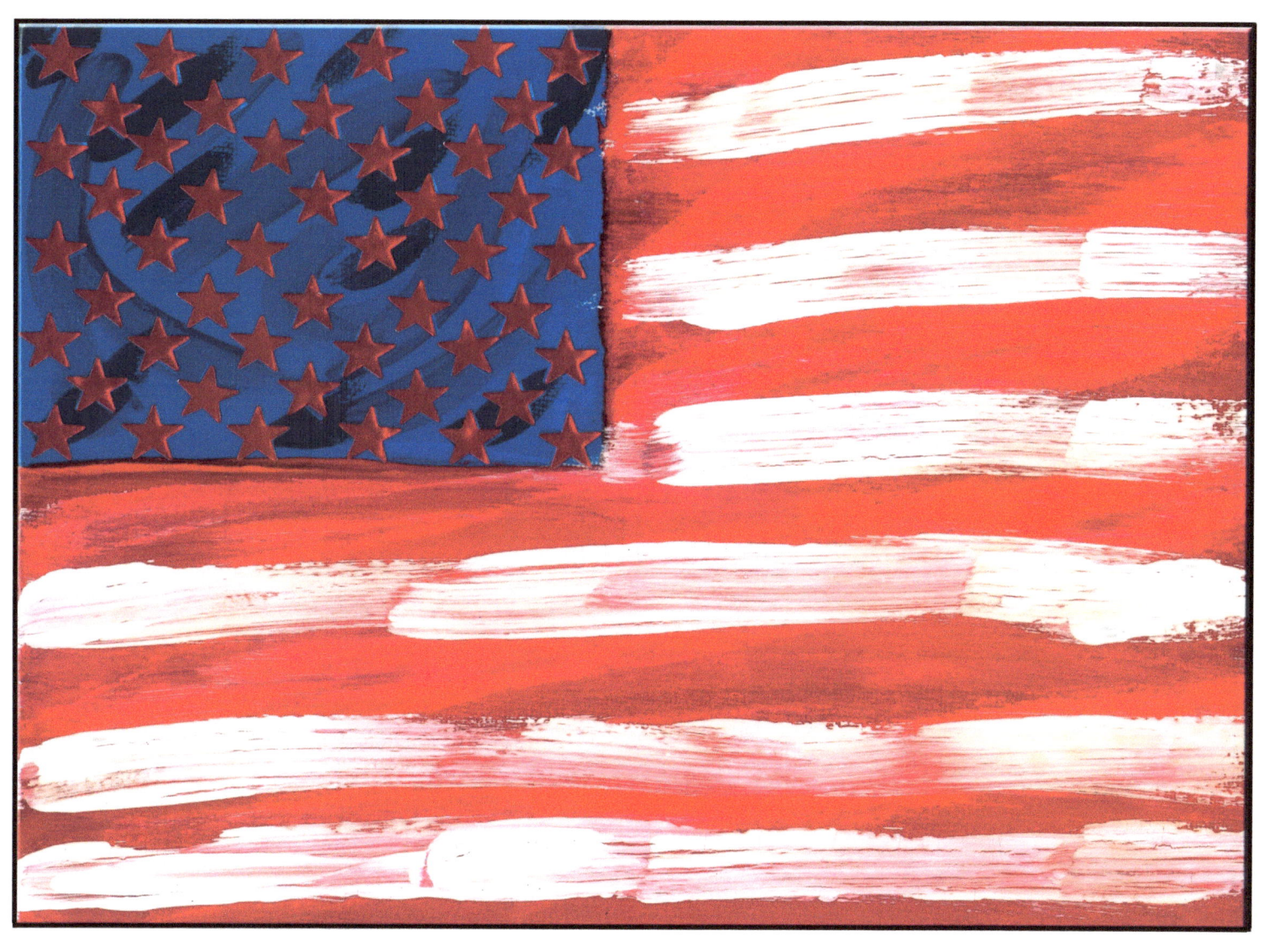

Adaptability

42

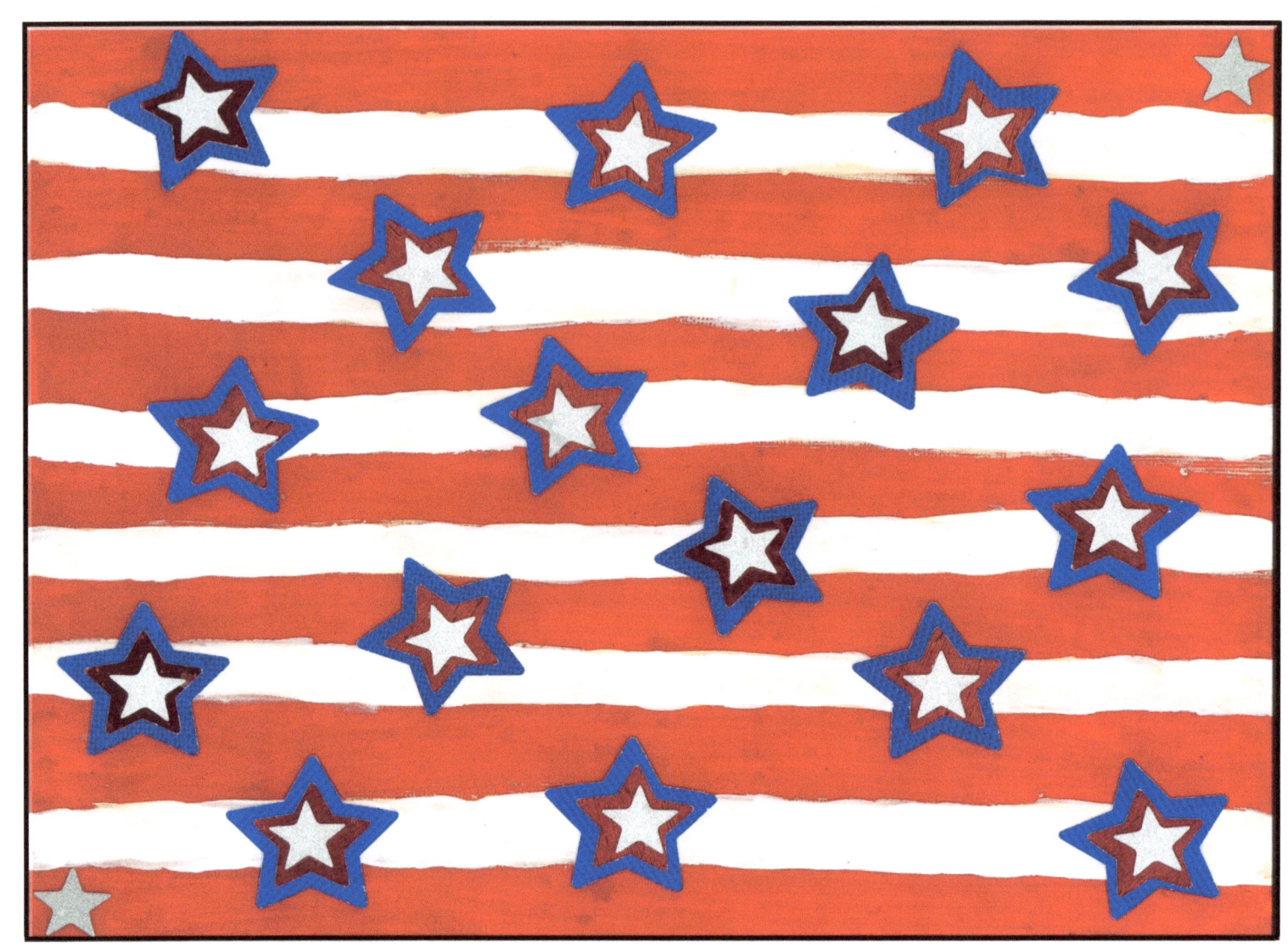

Dependability

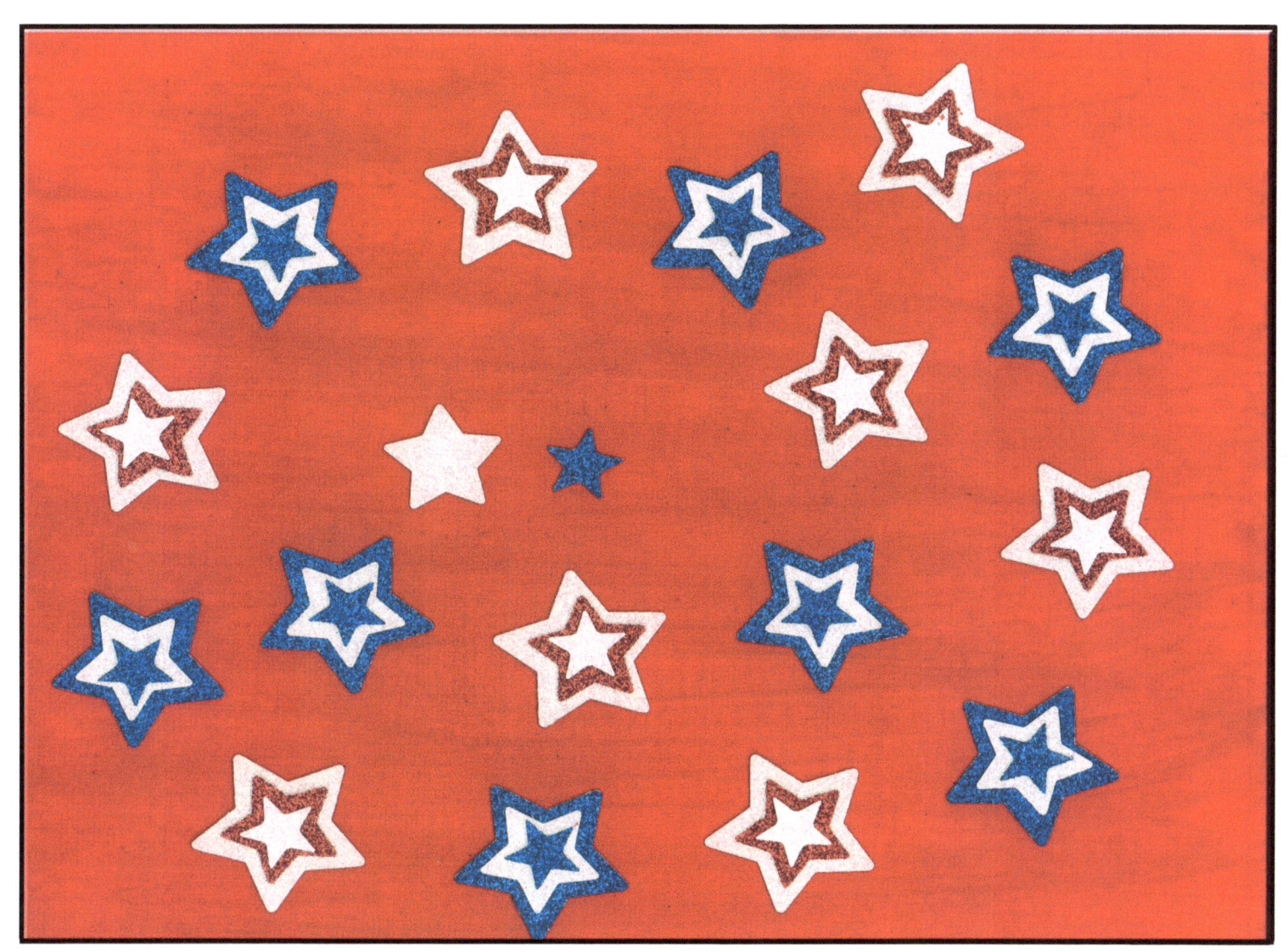

Reliability

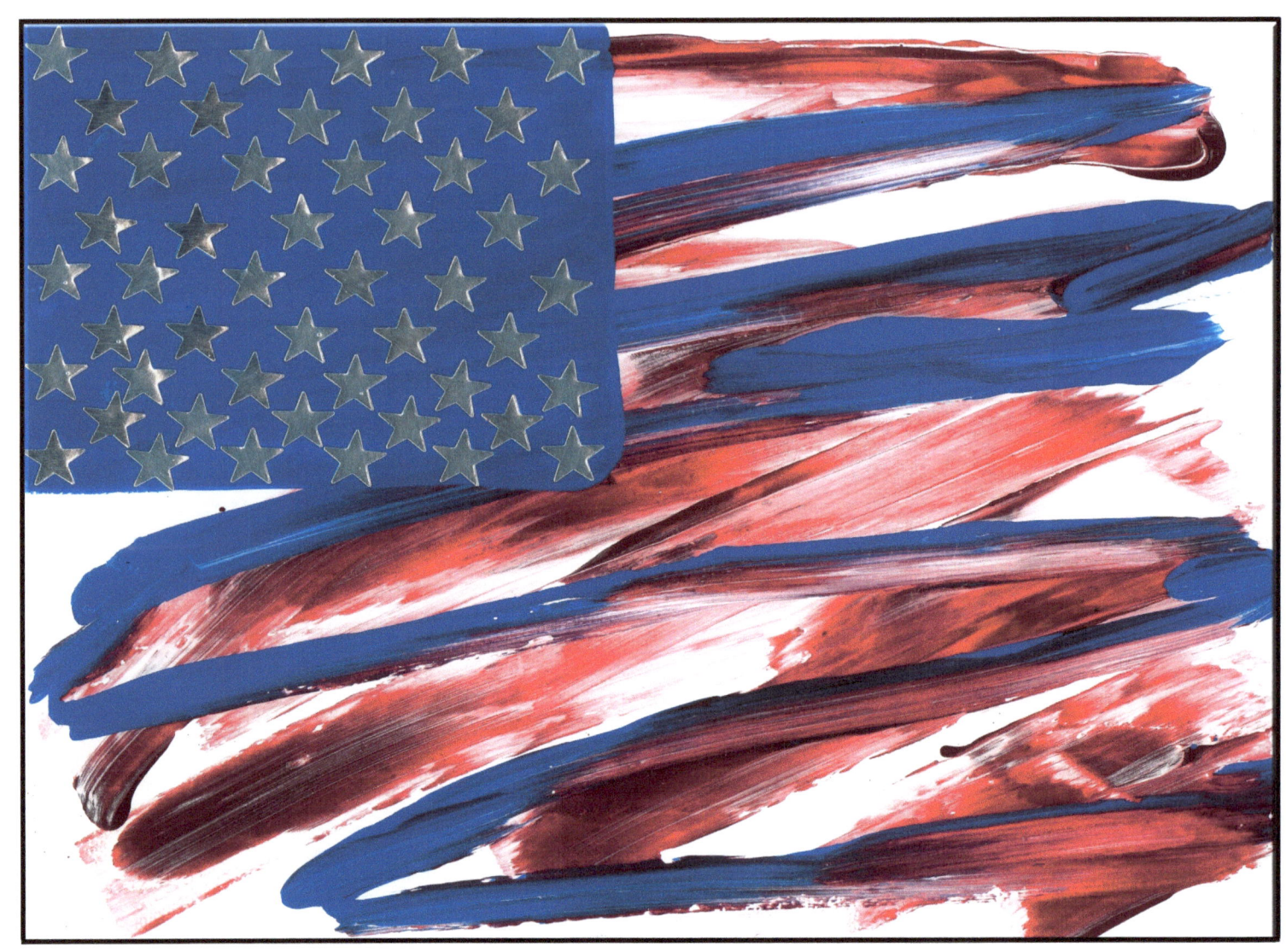

Understanding

45

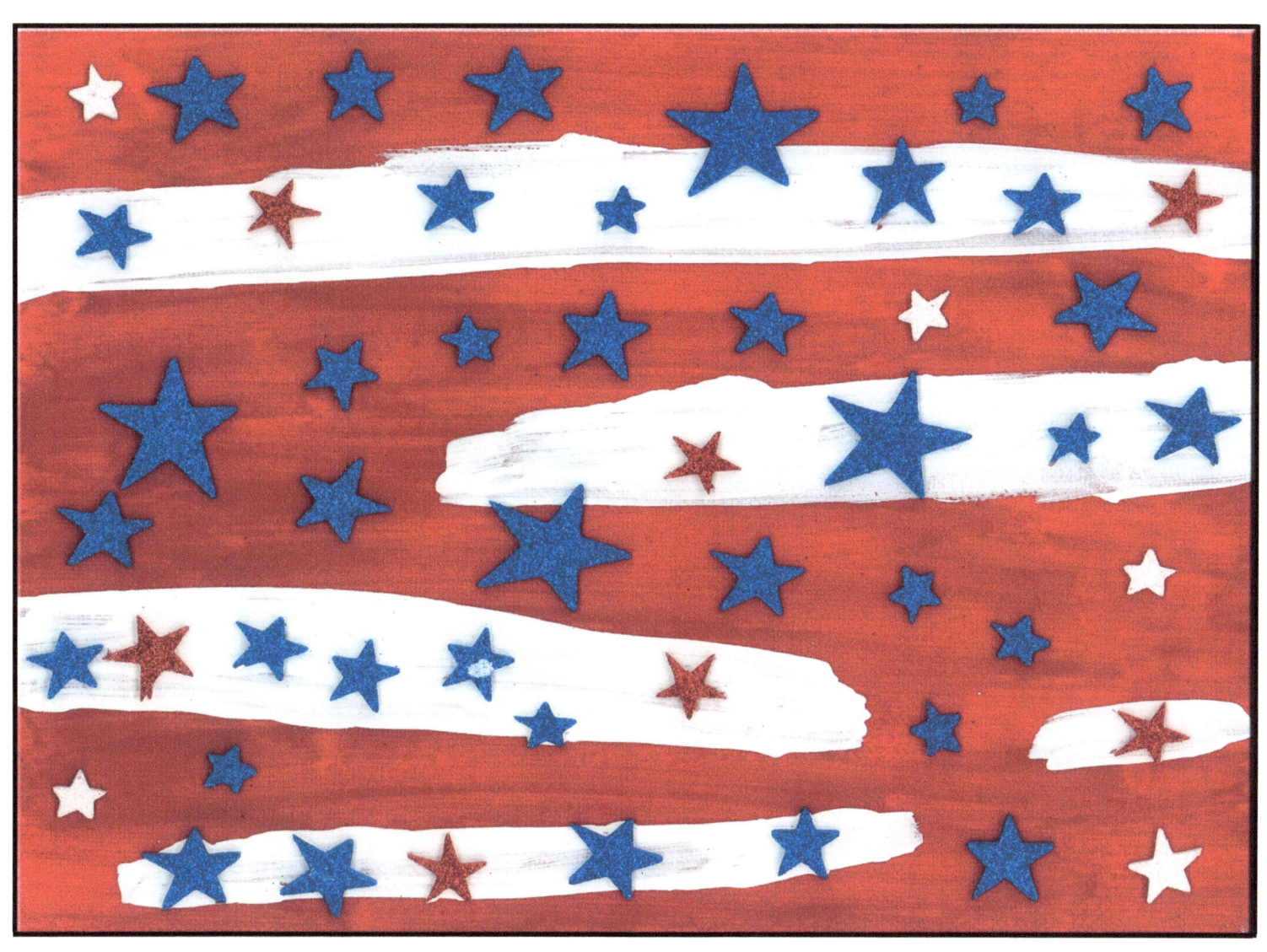

Compassion

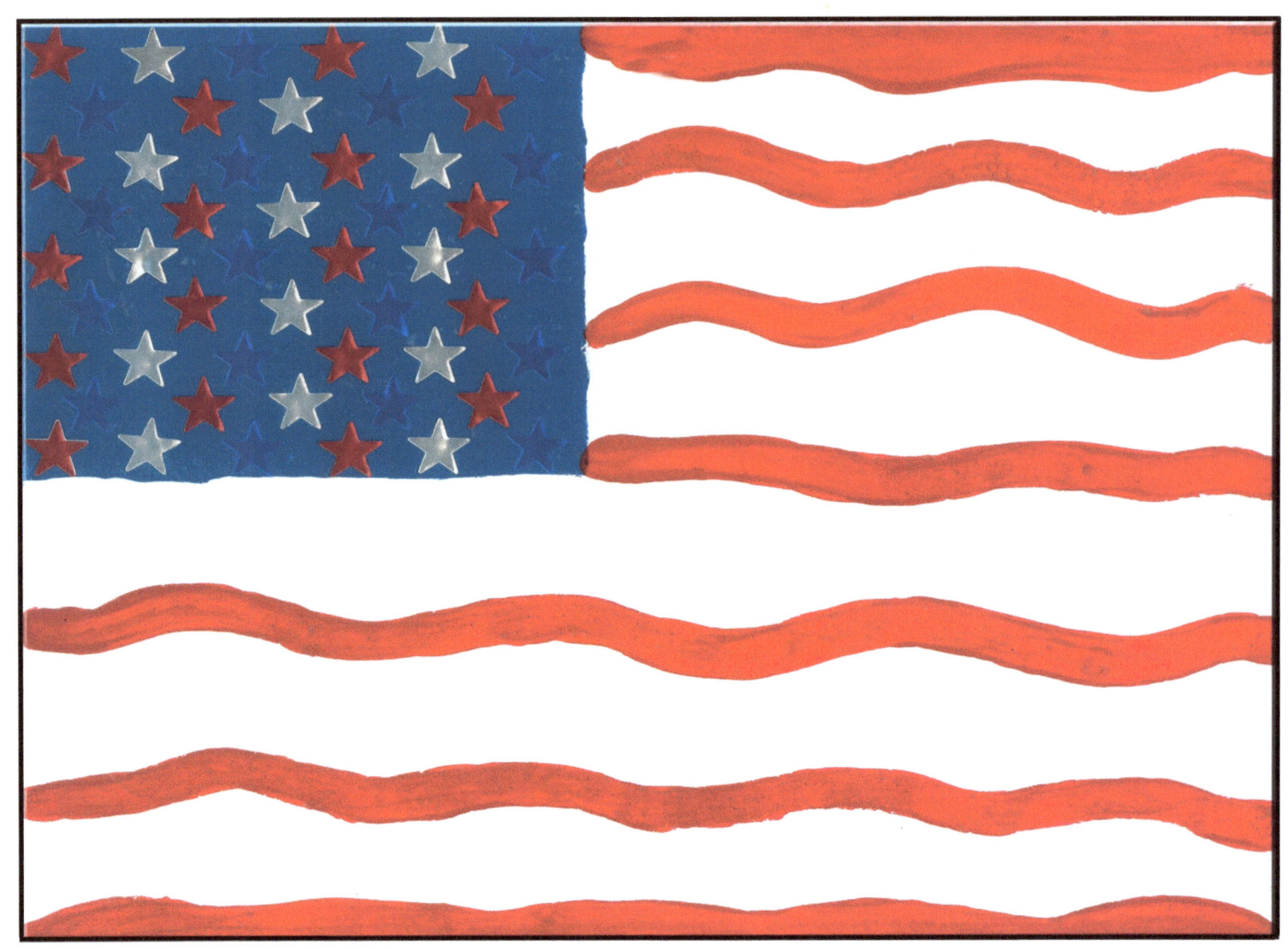

Patience

47

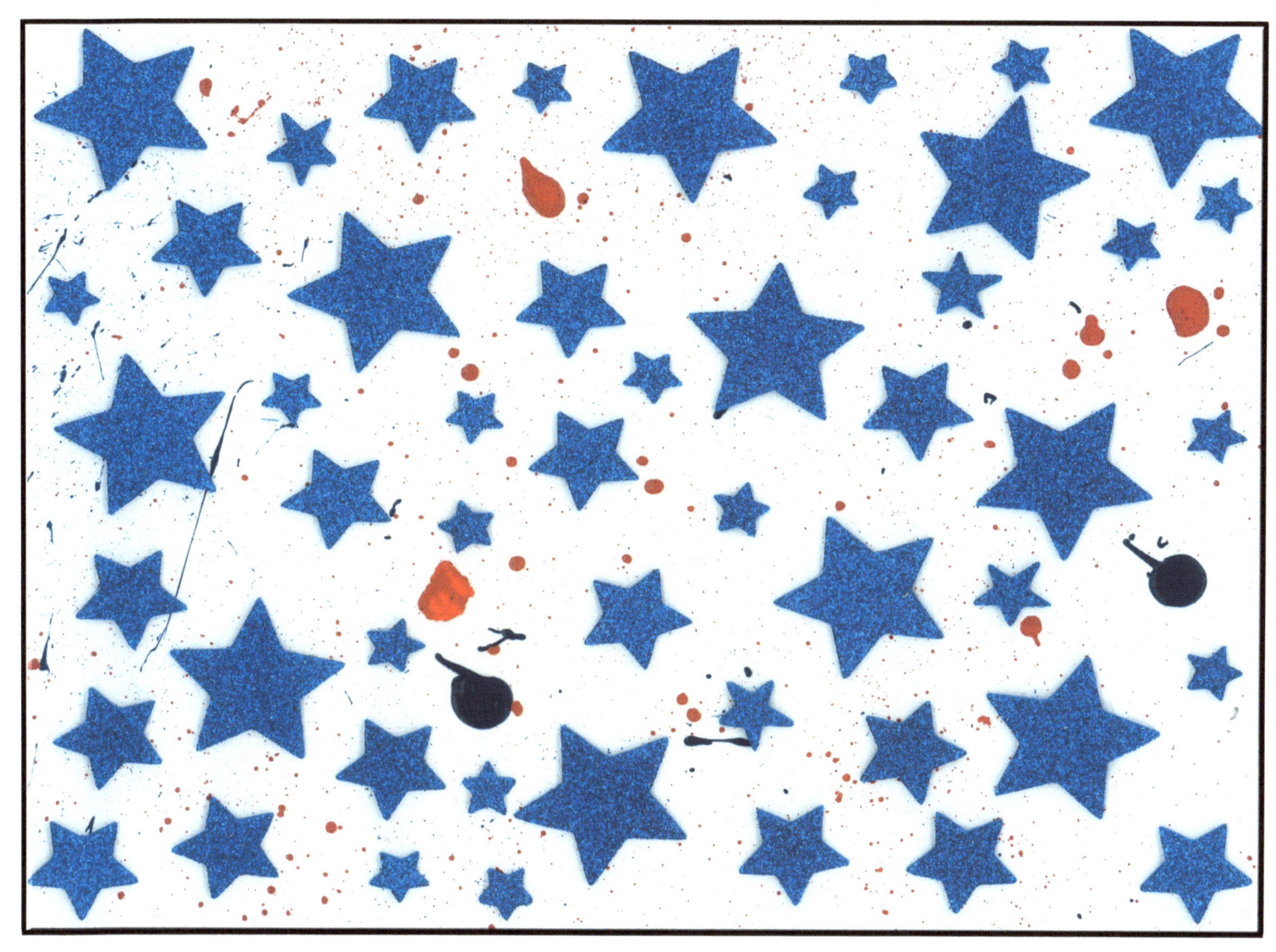

Care

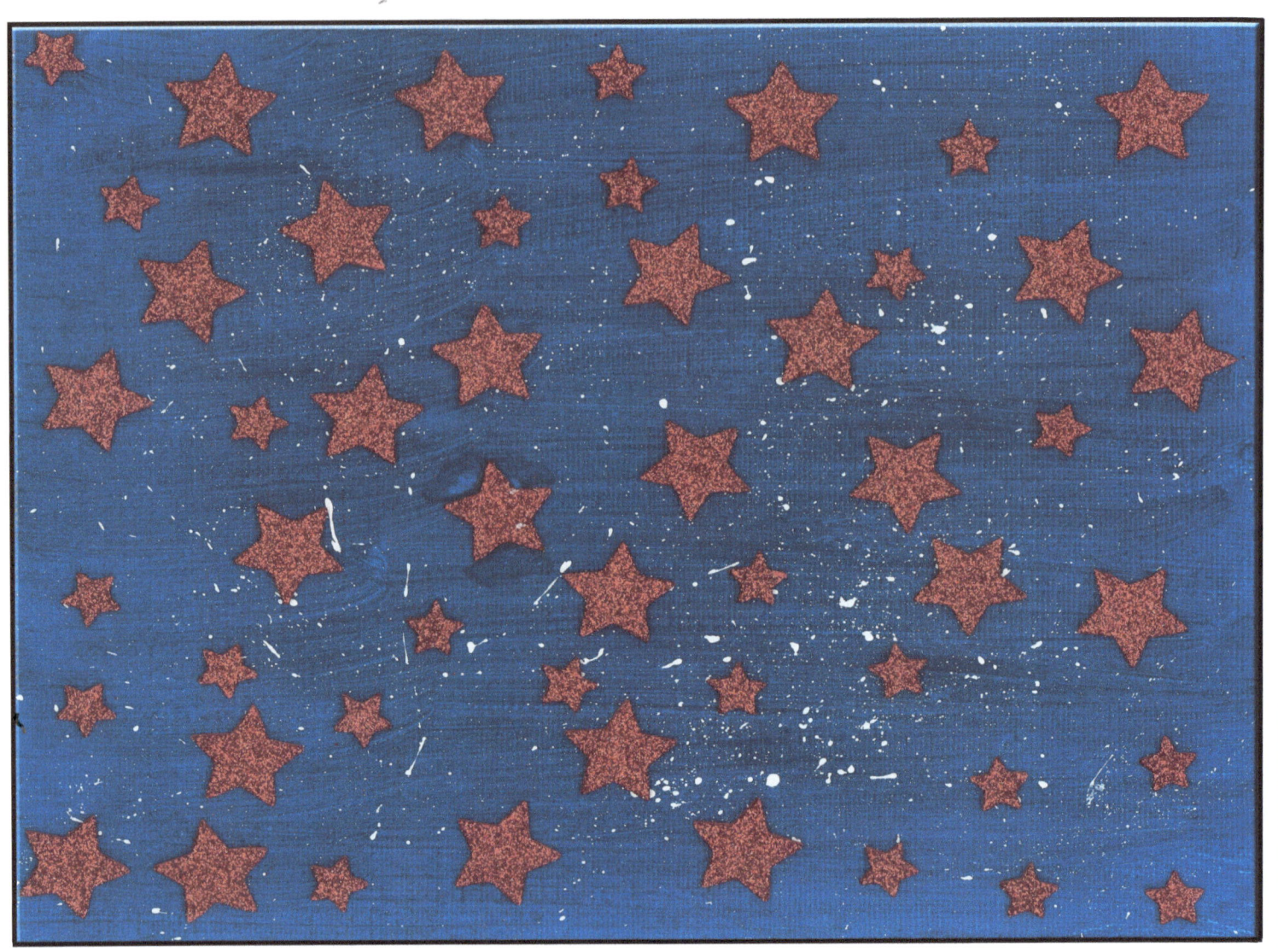

Peace

49

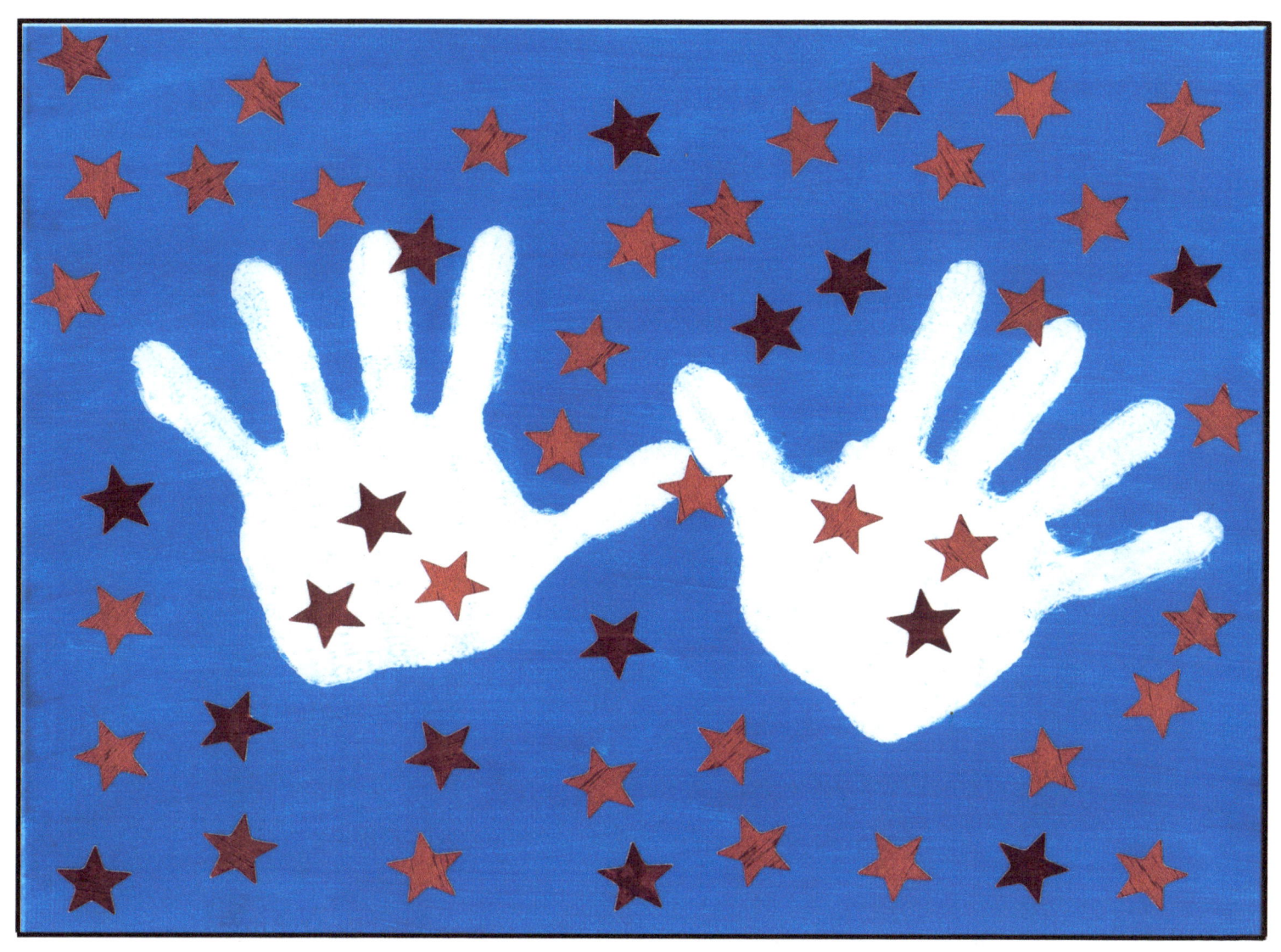

Love

50

1. **Military** - members of the armed forces : (such as the army, navy, marines, and air force)
2. **Police Officer** - a person whose job is to enforce laws, investigate crimes, and make arrests : a member of the police
3. **Firefighter** - a member of a group that works to put out fires
4. **Emergency Medical Technician (EMT)** - a person who is trained to provide emergency medical services to patients who are being taken to a hospital
5. **K-9 Unit aka Police Dog** - a dog that is trained to help police find criminals and illegal drugs
6. **Best Friend** - a person who you like and enjoy being with : a person who helps or supports someone or something
7. **United States of America** - country in North America
8. **Stars and Stripes** - the flag of the United States
9. **Oath** - a formal and serious promise to tell the truth or to do something
10. **Duty** - something that is done as part of a job
11. **Liberty** - the state or condition of people who are able to act and speak freely
12. **Freedom** - the state of being free
13. **Law** - the whole system or set of rules made by the government of a town, state, country, etc.
14. **Justice** - the process or result of using laws to fairly judge crimes and punish criminals
15. **Service** - an organization, company, or system that provides something to the public
16. **Protection** - the state of being kept from harm, loss, etc. : the state of being protected
17. **Community** - a group of people who live in the same area (such as a city, town, or neighborhood)
18. **Family** - a group of people who are related to each other or not related to each other, but are consider to be part of the family.
19. **Sacrifice** - the act of giving up something that you want to keep or to do something to help someone
20. **Honor** - respect that is given to someone who is admired
21. **Heroes** - a person who is admired for great or brave acts or fine qualities
22. **Courage** - the ability to do something that you know is difficult or dangerous
23. **Strength** - the quality or state of being physically strong : the quality that allows someone to deal with problems in a determined and effective way
24. **Safety** - freedom from harm or danger : the state of being safe
25. **Respect** - a feeling of admiring someone or something that is good, valuable, important, etc.

26. **Trust** - belief that someone or something is reliable, good, honest, effective, etc.
27. **Leadership** - a position as a leader of a group, organization, etc.
28. **Teamwork** - the work done by people who work together as a team to do something
29. **Loyalty** - a loyal feeling : a feeling of strong support for someone or something
30. **Honesty** - the quality of being fair and truthful : the quality of being honest
31. **Dedication** - a feeling of very strong support for or loyalty to someone or something : the quality or state of being dedicated to a person, group, cause, etc.
32. **Discipline** - a way of behaving that shows a willingness to obey rules or orders : behavior that is judged by how well one follows a set of rules or orders
33. **Persistence** - the quality that allows someone to continue doing something or trying to do something even though it is difficult or opposed by other people
34. **Advocate** - a person who argues for or supports a cause or policy : a person who works for a cause or group
35. **Intelligent** - having or showing the ability to easily learn or understand things or to deal with new or difficult situations : having or showing a lot of intelligence
36. **Good Listener** - to pay attention to someone or something in order to hear what is being said, sung, played, etc. : to hear what someone has said and understand that it is serious, important, or true
37. **Integrity** - the quality of being honest and fair
38. **Punctuality** - arriving or doing something at the expected or planned time : being on time
39. **Responsibility** - the state of having the job or duty of dealing with and taking care of something or someone : the quality of a person who can be trusted to do what is expected, required, etc.
40. **Accountability** - required to be responsible for something
41. **Flexibility** - willing to change or to try different things
42. **Adaptability** - able to change or be changed in order to fit or work better in some situation or for some purpose : able to adapt or be adapted
43. **Dependability** - able to be trusted to do or provide what is needed : able to be depended on
44. **Reliability** - able to be trusted to do or provide what is needed : able to be relied on
45. **Understanding** - the knowledge and ability to judge a particular situation or subject : a willingness to understand people's behavior and forgive them
46. **Compassion** - a feeling of wanting to help someone who is sick, hungry, in trouble, etc.
47. **Patience** - the ability to remain calm and not become annoyed when dealing with problems or with difficult people
48. **Care** - effort made to do something correctly, safely, or without causing damage : things that are done to keep someone healthy, safe, etc.
49. **Peace** - a state in which there is no war or fighting
50. **Love** - a feeling of great interest, affection, or enthusiasm for something

Source http://Learnersdictionary.com/

Dedication:
Thank you to all uniformed personnel for your service and continued protection over the United States of America.

Inspiration:
I created *Serve* to acknowledge and honor all uniformed personnel who serve and protect our country. Making 50 flags by using 8 x 10 canvases with acrylic paint and custom stars, I chose the United State's flag because it is the symbol of our freedom which all uniformed personnel swear to, under oath. Let's celebrate all uniformed personnel and honor them respectfully.

Serve

Written and Illustrated by Jacquelyn Jaie Fourgerel

Copyright: 2016 Jacquelyn Jaie Fourgerel. All Rights Reserved.

No part of this book may be reproduced, stored in a retrieval system, or transmitted by any means without the written permission of the author.

Printed by: CreateSpace, an Amazon Company 2016

ISBN- 13: 978-1534664562

ISBN- 10: 1534664564

Website: jacquelynfourgerel.com

www.ingramcontent.com/pod-product-compliance
Lightning Source LLC
Chambersburg PA
CBHW050810180526

45159CB00004B/1621